King
Charles III

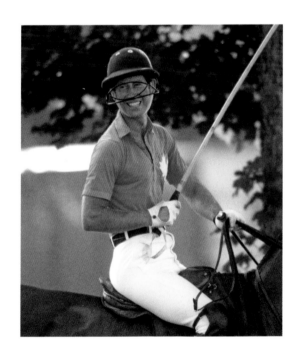

King Charles III

Gill Knappett

Contents

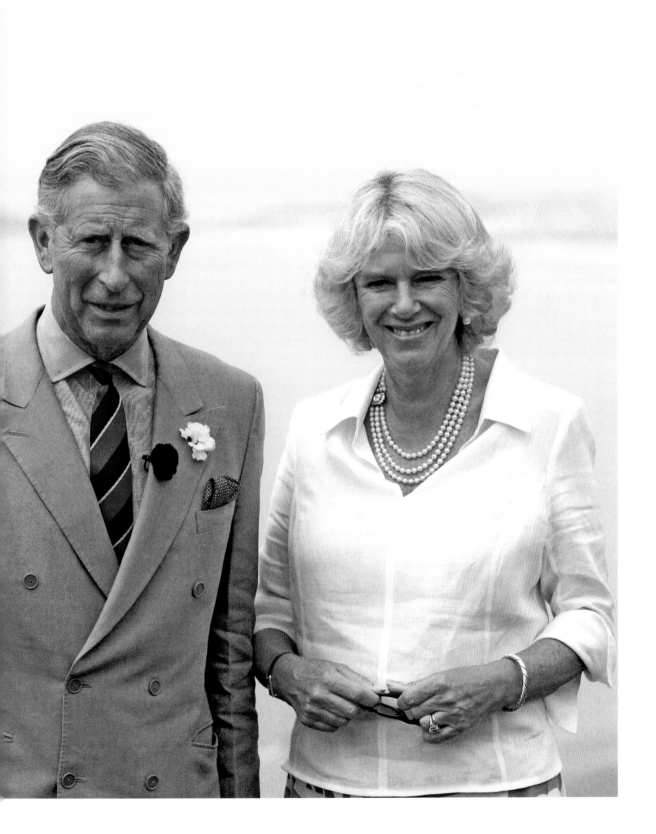

King Charles III Timeline

1948 Prince Charles Philip Arthur George is born on 14 November, the first child of Princess Elizabeth and Prince Philip, and second in line to the throne.

1952 King George VI dies in February and Prince Charles' mother accedes the throne as Queen Elizabeth II.

1956 After being taught at home, Prince Charles starts at Hill House School, Knightsbridge; he becomes a boarder at Cheam School in Hampshire the following year.

1958 The nine-year-old Charles learns that he is to become Prince of Wales.

1962 In May, Prince Charles starts his secondary education at Gordonstoun in Scotland.

1967 Prince Charles goes up to Trinity College, Cambridge, graduating three years later.

1968 Prince Charles is invested as a Knight of the Garter at St George's Chapel, Windsor.

1969 Prince Charles is invested as the Prince of Wales at Caernarfon Castle on 1 July.

1971 The Prince of Wales begins his military career at RAF Cranwell, Lincolnshire in March; in September he starts at the Royal Naval College, Dartmouth.

1972 Prince Charles is introduced to Camilla Shand (later Mrs Parker Bowles) by a mutual friend.

1976 Prince Charles launches The Prince's Trust in June; after completing his final tour of duty he leaves the Royal Navy in December.

1977 Prince Charles is introduced to 16-year-old Lady Diana Spencer by her sister, Sarah.

1979 Prince Charles is devastated when his great-uncle, Earl Mountbatten of Burma, is killed by an IRA bomb in Northern Ireland; that same year Charles founds the Prince of Wales' Charitable Foundation.

1980 The Highgrove Estate near Tetbury in Gloucestershire is purchased for Prince Charles by the Duchy of Cornwall.

1981 The Prince of Wales and Lady Diana Spencer are engaged in February and marry at St Paul's Cathedral on 29 July.

1982 Prince William Arthur Philip Louis, the first child of the Prince and Princess of Wales, and second in line to the throne, is born on 21 June.

1984 In May, Prince Charles famously speaks out about his concerns regarding the effect of modern British architecture on ordinary people; Prince Henry Charles David Albert (Harry) is born on 15 September, a brother to Prince William.

1993 Poundbury, an urban extension of Dorchester in Dorset, is started in 1993 on land owned by the Duchy of Cornwall.

1996 The Prince and Princess of Wales are divorced; she dies in a car crash the following year.

2002 The Queen Mother dies aged 101; from Highgrove, Prince Charles gives a moving tribute to his grandmother.

2005 Prince Charles and Camilla Parker Bowles are engaged in February and marry in Windsor in April; she is known by the title Duchess of Cornwall.

2011 Prince Charles' eldest son, Prince William, marries Catherine Middleton at Westminster Abbey; they are bestowed the titles Duke and Duchess of Cambridge.

2013 Prince Charles becomes a grandfather for the first time when Prince George Alexander Louis is born on 22 July – the first child of the Duke and Duchess of Cambridge and third in line to the throne.

2014 It is announced that The Queen is to relinquish some of her royal duties which are to be shared between her four children and Princes William and Harry.

2018 Prince Charles' youngest son, Prince Harry, marries Meghan Markle at St George's Chapel, Windsor; they are bestowed the titles Duke and Duchess of Sussex.

2020 The Duke and Duchess of Sussex announce their plans to give up their royal duties and move to the USA.

2021 Prince Charles' father, the Duke of Edinburgh, dies on 9 April.

2022 Prince Charles' mother, Queen Elizabeth II, dies on 8 September; his ascension to the throne as King Charles III heralds the third Carolean age.

The effigy of King Charles III to be used on new coins and banknotes was revealed by the Royal Mint on 29 Sept 2022. The portrait first appeared on a £5 coin (shown here) and a 50p coin, which became available on 3 October 2022 and were issued to commemorate the life and legacy of Queen Elizabeth II.

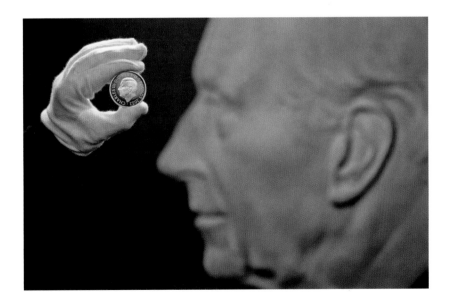

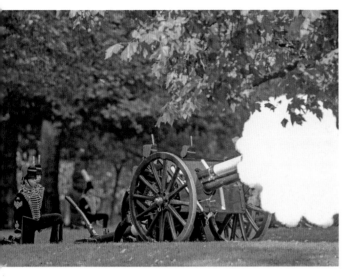

God Save The King

At 6.30pm on Thursday 8 September 2022 came the announcement from Buckingham Palace: 'The Queen died peacefully at Balmoral this afternoon.' It was the end of the second Elizabethan era and the beginning of a new Carolean age.

The death of Her Majesty Queen Elizabeth II had not been entirely unexpected. When she celebrated her Platinum Jubilee earlier in the year, the number of times she appeared in public were far fewer than anyone – she included – might have wished. But her appearances on the balcony at Buckingham Palace – at Trooping the Colour on 2 June and the finale of the four-day pageant on 5 June – were received with rapturous warmth and affection. Two moments during those Jubilee celebrations were, for many, particularly special and will be long remembered: when The Queen bent down to chat to her four-year-old great-grandson Prince Louis during the Trooping the Colour RAF fly-past; and her appearance on BBC television in a charming and humorous sketch with none other than Paddington Bear.

The decline in The Queen's mobility in recent years had given cause for concern. But it was a slow decline and a long time before she gave in to using a walking stick for support, still wearing shoes with a small heel, still dressing immaculately on every

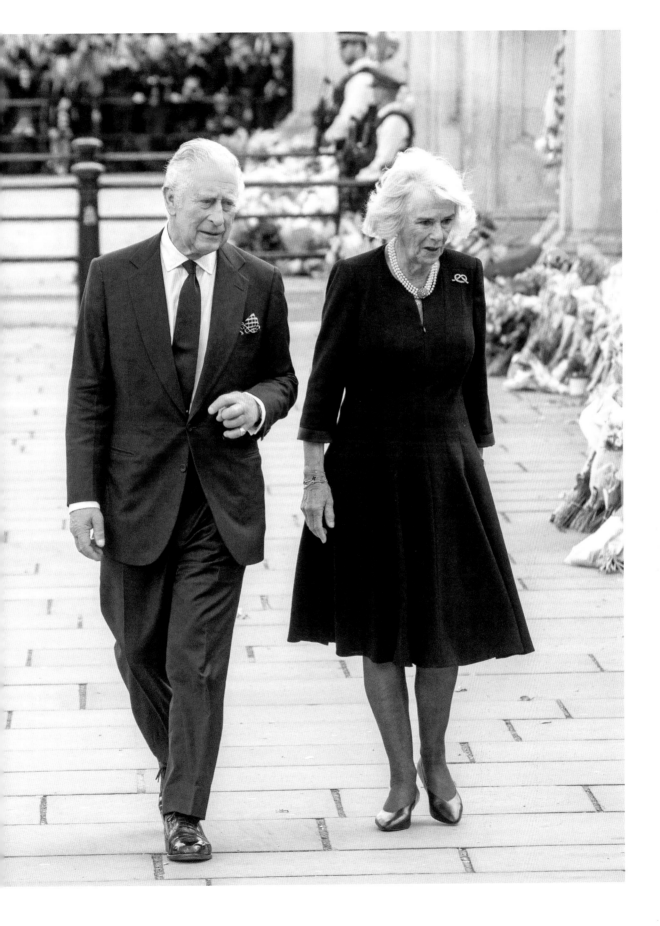

occasion, with matching stylish hats, classic handbags, perfectly coiffured hair … and that slick of lipstick, always such an important part of persona.

It was reported that in October 2021 she underwent tests in hospital. Under doctors' orders to rest, she missed the Remembrance Sunday service at the Cenotaph that November. After contracting Covid-19 in February 2022 she as left 'tired and exhausted'.

In July 2022, Her Majesty headed to Balmoral for her traditional summer break. On 5 September, it was announced that Liz Truss had been chosen as the newly elected head of the Conservative Party. The following day, at an audience at Balmoral Castle, The Queen invited her to become Prime Minister and form a new government. This was history in the making: it was not only the first time such a meeting had been held at Balmoral rather than Buckingham Palace, but it was to be the last formal duty Her Majesty carried out. Two days later, at 12.30pm, Buckingham Palace announced that doctors were concerned for The Queen's health, that she was under medical supervision but comfortable. Six hours later came the news of her death. And the world changed.

The person for whom the biggest change came about was, of course, her son and heir, the man who is now King Charles III. It was he and his sister, the Princess Royal, who had been with Her Majesty at her passing. Fortunately, they were both already in Scotland on engagements and able to travel to

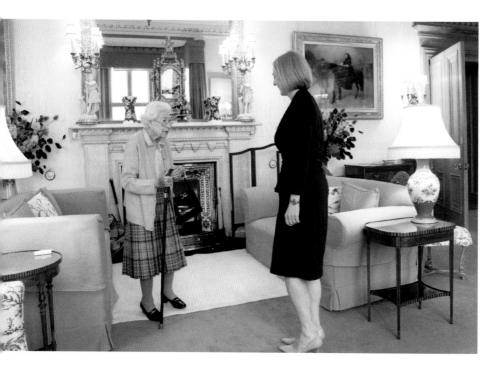

The Queen welcomes Liz Truss at Balmoral on 6 September 2022. It was to be Her Majesty's final official duty. In a remarkable twist of fate, it turned out to be a meeting between Britain's longest-serving monarch and shortest-serving Prime Minister.

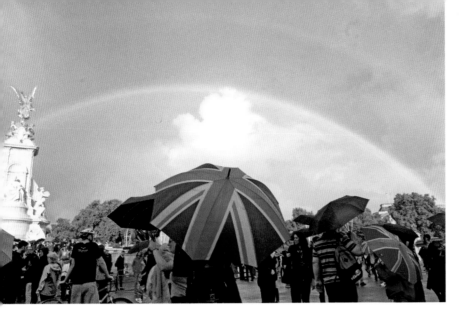

On 8 September 2022, a rainbow appeared in the grey skies above the Queen Victoria Memorial outside Buckingham Palace as crowds gathered, following news of concerns for the health of Her Majesty Queen Elizabeth II.

Balmoral swiftly. Meanwhile her other children and some of her grandchildren had been called and were flying up to Scotland. It was not until later in September, when Her Majesty Queen Elizabeth's death certificate was made public, that we learned that she died at 3.10pm and that the cause was simply 'old age'. Prince Andrew, Prince Edward (along with his wife Sophie) and Prince William had arrived at Balmoral at around 5pm on that fateful day, and Prince Harry around 8pm: sadly, too late for a final goodbye.

The messages of condolences and tributes to The Queen exceeded anything experienced before. Those who remember the tragic death of Diana, Princess of Wales in 1997 will recall the tide of public grief her passing elicited, and the thousands of bouquets of flowers placed at the gates of Buckingham Palace and Kensington Palace in tribute to her. But even this could not compare to the tsunami of grief that The Queen's death unleashed.

In those days in early September 2022, as messages came that The Queen's health was giving concern, crowds of well-wishers began to gather outside Buckingham Palace, Windsor Castle and Balmoral Castle. On 8 September, in an extraordinarily timed phenomenon of nature, a rainbow shone through the heavy clouds above Buckingham Palace.

At 6.30pm, the Union flag flying over Buckingham Palace was lowered to half mast: the news everyone had dreaded was confirmed. Members of the Royal Household placed the notice confirming Her Majesty's passing on the palace gates. And in a spontaneous gesture, London taxis lined up on The Mall in silent tribute.

OPERATION LONDON BRIDGE

There are code names for the plan of action that swings into place as soon as the death of a senior member of the Royal Family takes place. For Queen Elizabeth II, the code name was Operation London Bridge.

Once news of The Queen's passing was made known, a period of national mourning began which was to last until Her Majesty's State Funeral had taken place. People came from all over the country and travelled from other nations to gather outside royal palaces and castles to lay flowers, light candles and leave messages in tribute to the only monarch most of her subjects had ever known. Over the coming days, so great was the number of floral tributes that the request came that they be taken instead to dedicated sites in Green Park, adjacent to Buckingham Palace. Similar areas were allocated at Windsor and Sandringham; at Balmoral and the Palace of Holyroodhouse in Scotland; and at Hillsborough Castle in Northern Ireland.

On 9 September, King Charles III and his Queen Consort returned from Balmoral to London. They were visibly moved by the warm reception they received from the crowds outside Buckingham Palace. As the couple walked among their people, they were greeted with shouts of 'God save The King' and calls for 'Three cheers for The King!'

It was from Buckingham Palace later that day that King Charles gave his first televised address to the nation and Commonwealth as monarch. His faced etched with grief, His Majesty opened with the words: 'Queen Elizabeth's was a life well lived; a promise with destiny kept and she is mourned most deeply in her passing.' He acknowledged his sorrow at the loss of 'Her Majesty The Queen – my beloved Mother'. He referred to his family and how in this time of change he would 'count on the loving help of my darling wife, Camilla', now his Queen Consort, and of his pride in the new Prince and Princess of Wales. He spoke movingly and eloquently of The Queen's life of service, of devotion to duty, and pledged that he too will serve 'with loyalty, respect and love, as I have throughout my life'. After thanking everyone for the condolences and support his family had received, he ended by thanking his 'darling Mama' as she began her last journey to join 'my

dear late Papa'. His Majesty closed with a quote from Shakespeare's *Hamlet*: 'May "flights of angels sing thee to thy rest".'

The following day, the Accession Council met to proclaim Charles as the new sovereign. At the age of 73, he became the oldest monarch in British history to take the throne.

And so 'The Queen is dead, long live The King'. This phrase – or versions of it – is indicative of the fact that the monarchy is ongoing, without pause, as the new sovereign accedes the throne immediately on the death of his, or her, predecessor. It is thought that the words were first used in 1422, on the death of Charles VI of France and the accession of his son, Charles VII. *'Le roi est mort, vive le roi!'* was adopted and translated by other countries around the world.

The passing of Queen Elizabeth II was a momentous event for our nation and for the Commonwealth. When choirs in city cathedrals, village churches and school assemblies throughout the land sang, for the first time, 'God Save the King' – the version of the National Anthem that had not been sung for 70 years – it was a moment for thoughtful reflection, but also, importantly, a time to rejoice in our new monarch: King Charles III.

'God save our gracious King! Long live our noble King! God save the King!
Send him victorious, Happy and glorious, Long to reign over us: God save the King!'

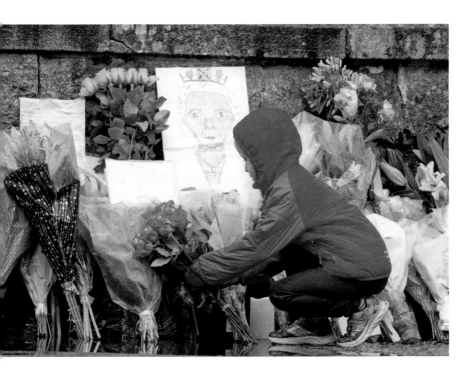

A young girl adds roses to the other floral tributes, drawings and messages left at the entrance to Balmoral Castle following the announcement that The Queen had died.

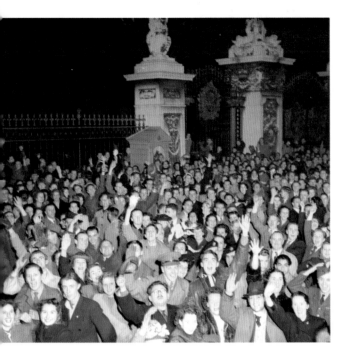

A Future King is Born

'The Princess Elizabeth, Duchess of Edinburgh was safely delivered of a Prince at nine fourteen pm today. Her Royal Highness and her son are both doing well.'

The hand-written note attached to the Buckingham Palace railings by King George VI's press secretary on 14 November 1948 raised a cheer and a rendition of 'For He's a Jolly Good Fellow' from the crowds who had gathered outside as they waited for news of the royal birth.

That the 7lb 6oz baby was a boy meant that Princess Elizabeth and Prince Philip's firstborn would one day be monarch. Had the baby been a girl, she would have taken her place behind any future brothers in the line of succession, as dictated by the Succession to the Crown Act first formed in 1701 – an Act that was changed in 2013 to give girls born after 28 October 2011 equal succession rights.

The wedding of Princess Elizabeth and Prince Philip – newly titled the Duke of Edinburgh on his marriage – on 20 November 1947 had been just the tonic

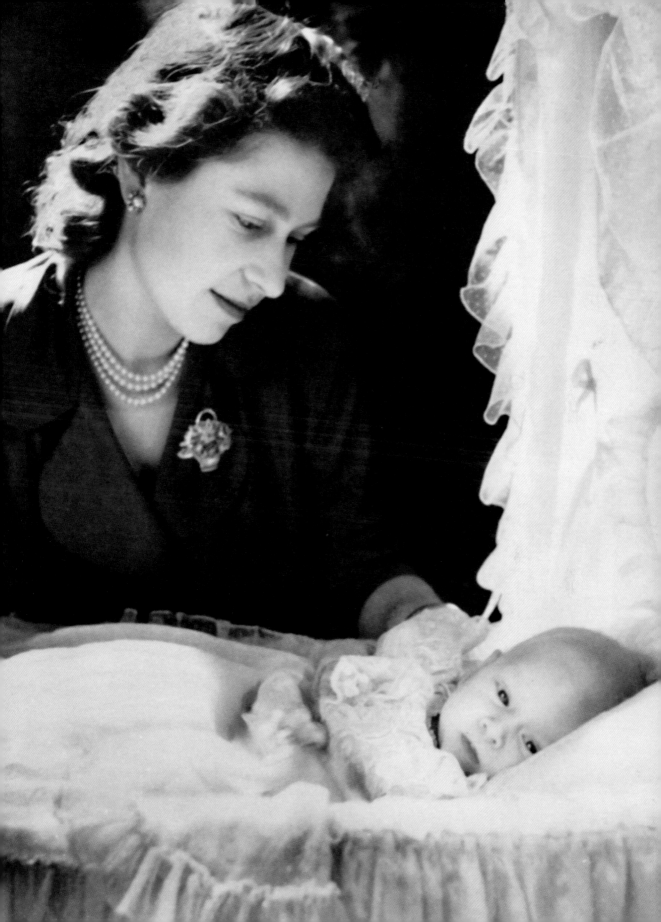

CHANGING THE COURSE OF HISTORY

Unlike her son, Princess Elizabeth had not been born to reign. It was only the abdication of her uncle, Edward VIII, in December 1936, followed by the accession of his younger brother, Elizabeth's father, as King George VI that meant the Princess became first in line to the throne.

post-war Britain needed, and the arrival of their first child a year later only added to the nation's joy. Their son was the first royal baby to be born without the Home Secretary in attendance, as had been tradition until that point. However, the boy was born at home – in the ornate Buhl Room at Buckingham Palace, converted into a delivery suite – rather than in hospital, another royal tradition that did not change until 1982.

Despite regular bulletins about the new arrival, one thing remained a mystery: his name. Speculation was rife but the name of the next heir to the throne was not announced until his christening a full month later. On 15 December 1948, it finally became public knowledge: the baby was called Charles Philip Arthur George. Many people were surprised at the choice of the name Charles, which had not been used by the Royal Family for more than 300 years after the traumatic reigns of Charles I and Charles II.

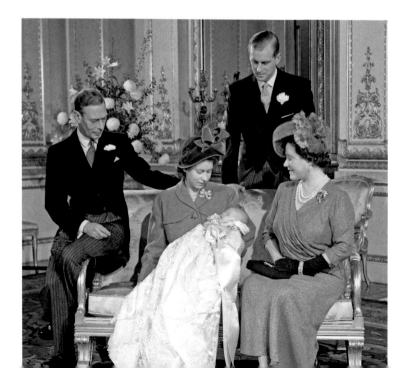

Princess Elizabeth holds a sleeping Prince Charles after his christening. Pictured with them are King George VI, Queen Elizabeth and the Duke of Edinburgh.

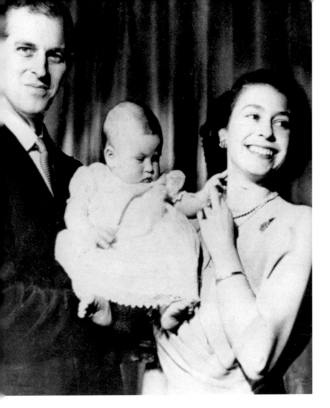

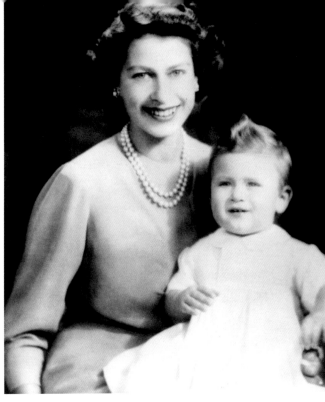

Princess Elizabeth and the Duke of Edinburgh, delighting in six-month-old Prince Charles.

A first-birthday portrait: Prince Charles with his mother, November 1949.

The christening for the boy born to be King took place in the Music Room of Buckingham Palace, an imposing columned chamber with a high-domed ceiling and arched windows. The service was conducted by the Archbishop of Canterbury who baptised the Prince with water from the River Jordan in the silver-gilt Lily Font, commissioned by Queen Victoria and first used in 1841 for the christening of her first child. HRH Prince Charles of Edinburgh was dressed in the Honiton lace christening gown worn by royal babies since the days of Queen Victoria.

The child was surrounded by his family and godparents, known as sponsors in royal circles. His eight sponsors were: King George VI (his maternal grandfather); Queen Mary (his maternal great-grandmother); the Dowager Marchioness of Milford Haven (his paternal great-grandmother); King Haakon VII of Norway (his cousin, represented at the ceremony by the Earl of Athlone, his maternal great uncle); Prince George of Greece and Denmark (his paternal great-uncle, represented at the ceremony by the Duke of Edinburgh); David Bowes-Lyon (his maternal great uncle); Princess Margaret (his maternal aunt); Lady Brabourne (his cousin).

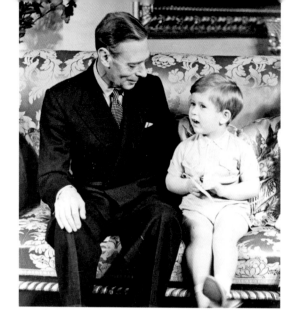

LEFT: King George VI was recovering from a lung operation when he was photographed with Prince Charles at Buckingham Palace on his grandson's third birthday. One of Charles' greatest regrets is never having a chance to really know his maternal grandfather, who died three months after this photograph was taken.

OPPOSITE: Princess Elizabeth with Prince Charles and Princess Anne on the baby's first birthday, 15 August 1951.

A Royal Upbringing

In 1949 the three-strong family moved into the newly refurbished Clarence House, Charles safely established in his blue and white nursery and sleeping in a cot that had belonged to both his mother and aunt, Princess Margaret.

Though his parents delighted in their baby son, the nursery was overseen by nanny Helen Lightbody, an experienced Scottish nanny with a strict manner, and her young assistant, Mabel Anderson. Mabel was 22 – the same age as Princess Elizabeth – when she replied to an advertisement for an assistant nanny, little knowing it was for the Royal Household. It was she who put the young Prince to bed, made sure he brushed his teeth, read him stories, taught him to say his prayers. Mabel (nicknamed 'Mipsy' by her young charge) was, in Prince Charles' words, 'a haven of security' and remained an important part of his life.

The busy Princess Elizabeth was, at times, absent for extended periods during Charles' infancy. She spent time in Malta with Prince Philip when he was posted there in the autumn of 1949 as second-in-command of HMS *Chequers*, the ship that led the first destroyer flotilla of the Mediterranean Fleet. The Princess celebrated her son's first birthday with him before flying to Malta to be with her husband for their second wedding anniversary. Young Charles remained at home in the care of his nannies and fond grandparents.

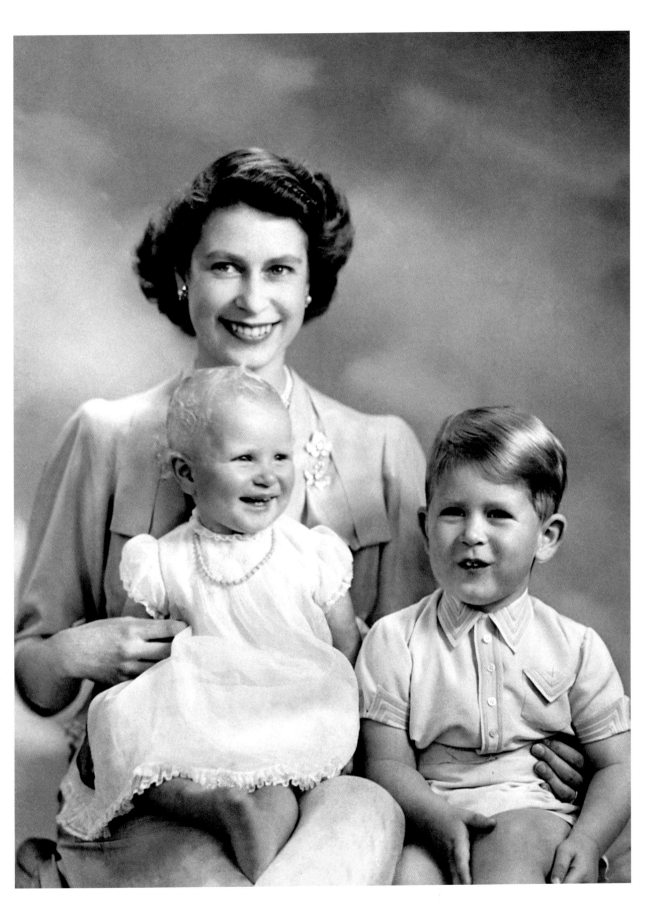

On 15 August 1950, Prince Charles' sister was born at Clarence House. Charles, not yet two, was joined in the nursery by the baby, christened Anne Elizabeth Alice Louise. Their mother returned to Malta in November that year, soon after Charles' second birthday, where Prince Philip had been made lieutenant commander of the frigate HMS *Magpie*.

Philip knew that his naval career was drawing to a close; his father-in-law's health was failing and plans were in place for the Edinburghs to make an official tour of Canada in autumn 1951. In July 1951, the young couple left Malta for the last time, Philip duty-bound to support his wife who was beginning to take on many of her parents' public engagements and whose workload was now considerable.

As Princess Anne grew, she and her elder brother became the best of playmates, despite their different natures. He was a thoughtful, shy and sensitive child; she a high-spirited tomboy. Their brusque father gravitated naturally towards his boisterous, outgoing daughter while trying to encourage his less confident son to develop a more robust character, knowing full well the life he would have to lead.

Charles was taught from the earliest age the high expectations and intense scrutiny that were the lot of an heir to the throne. Even as a small child, he was expected to make polite conversation and look people in the eye when speaking with them. Unlike his mother who had enjoyed ten years of a relatively carefree childhood before knowing she would one day be Queen, his life as the future King was marked out from day one.

When George VI died on 6 February 1952, aged just 56, his 25-year-old daughter became Queen Elizabeth II and Charles, at just three years old, was now heir apparent. On his mother's accession, Prince Charles acquired six hereditary titles: Duke of Cornwall, Duke of Rothesay, Earl of Carrick, Baron of Renfrew, Lord of the Isles, and Prince and Great Steward of Scotland. In September 2022, Prince William took on these titles.

Queen Elizabeth II's Coronation was planned for the following June, allowing for a period of mourning, time for the preparations to take place, and with the hope for bright, warm weather. While strategic arrangements were underway in the Royal Household, throughout the United Kingdom celebratory street parties were being planned.

One of Prince Charles' earliest memories is of being bathed by his nanny when his mother came into the nursery wearing St Edward's Crown, also known as the

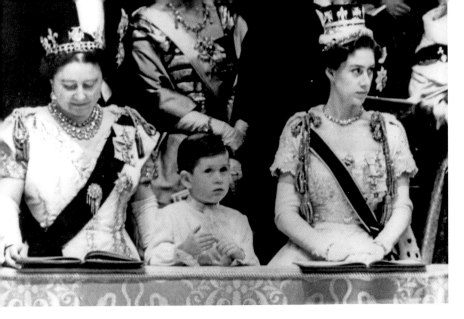

A well-behaved little boy: at Westminster Abbey, Prince Charles stands between the Queen Mother and Princess Margaret, watching as his mother is crowned Queen Elizabeth II.

Coronation Crown. She was practising carrying its great weight – 4lbs 6oz (about 2kg) of solid gold – in preparation for the forthcoming ceremony, and her small son was transfixed by the glittering jewels.

Following months of anticipation, the Coronation took place on 2 June 1953 at Westminster Abbey. Unlike his younger sister, Prince Charles, aged four, was deemed old enough to attend the ceremony and received a special hand-painted invitation. During the ceremony, Charles sat in the royal gallery between The Queen Mother and Princess Margaret. Sometimes, head on hand, he looked as bored as any child of his age might; at other times he appeared absorbed with the ritual, turning to his grandmother to ask questions.

Later in the day, the Royal Family, Princess Anne included, gathered on the balcony at Buckingham Palace to wave to the crowds who had thronged to greet their newly crowned Queen. Although the weather had turned out to be dull and wet, it had not dampened the spirits of Her Majesty's subjects.

MAKING BROADCASTING HISTORY

The BBC's televised coverage of The Queen's Coronation was a milestone in the history of broadcasting. It was the first service to be televised and, for many people, it was the first time they had watched television. As few households in Britain owned a television set back then, families with one welcomed friends and neighbours into their homes to see the event on the small screen.

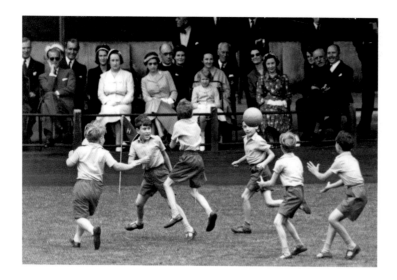

Schooldays

On her accession, the new Queen and her family moved into Buckingham Palace. Shortly before Prince Charles turned five, a room in the nursery was converted into a classroom where he was schooled by governess Catherine Peebles. He was responsive to kindness and worked hard, although he did not display any of the intellectual curiosity that would define him in adulthood.

Shortly before his eighth birthday, it was deemed that Charles would benefit from the company of other children. When he started at Hill House School in Knightsbridge in November 1956, he was the first heir to the throne to attend school beyond royal walls. He settled quietly into life as a schoolboy, showing an aptitude in several subjects, including art; his report the following year recorded that he 'simply loves drawing and painting'.

In September 1957, Charles became a boarder at Cheam School in Hampshire. Prince Philip had attended Cheam at the same age, and as it had helped develop his own resilient character he thought it would be ideal for his son. Charles, however, was terribly homesick and found it difficult to make friends. Fortunately, he had been taught to box and could defend himself in a tussle – but as a result of such behaviour he was beaten by the headmaster. Charles took his punishment well, later saying: 'I am one of those people for whom corporal punishment actually worked … I didn't do it again.'

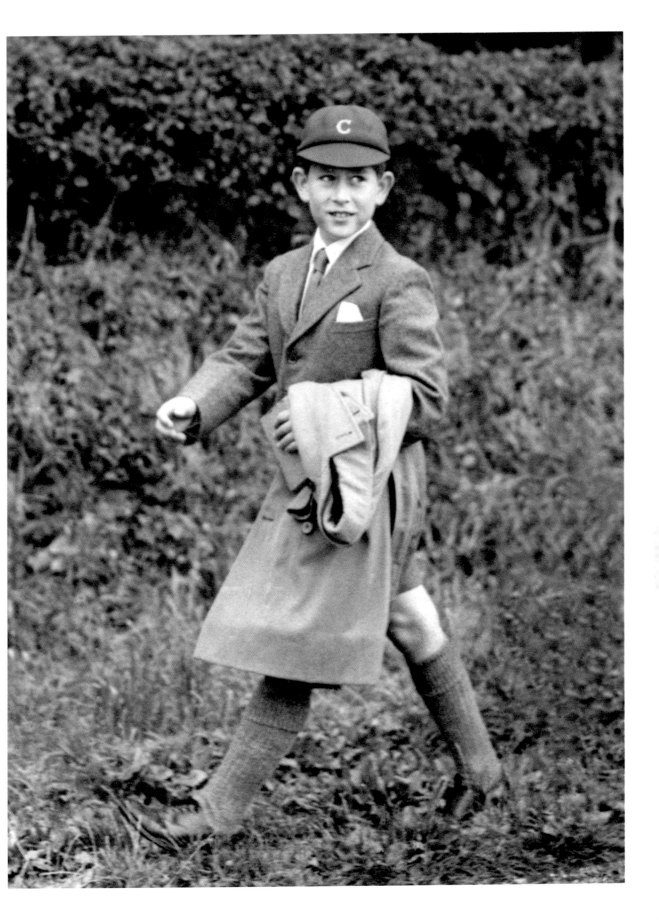

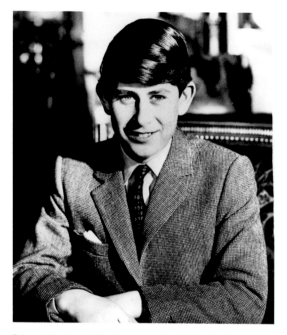 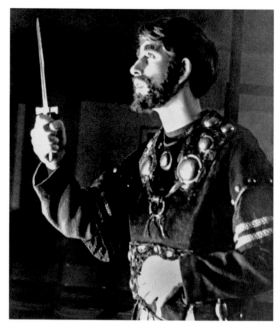

Prince Charles at Gordonstoun: his 1962 school photograph.

Prince Charles in the role of *Macbeth*, 1965.

Prince Philip also chose his son's secondary school: Gordonstoun, located on the Morayshire coast in an isolated part of north-east Scotland. Established in 1934, Philip had been one of the first students at Gordonstoun where the motto is *Plus est en vous* (There is more in you). Although his father loved his time there it was to be a very different story for 13-year-old Prince Charles, who later likened his ordeal to a 'prison sentence'.

The school had a 17th-century building at its centre, with prefabricated wooden huts – previously used as RAF barracks – for accommodation. The boys wore short trousers all year round, windows in the dormitories were open whatever the weather, and the school day began at 7.15am with a run and cold shower before breakfast.

Charles participated without complaint in all activities, including military-style assault courses, but found solace in pottery classes and classical music. While at Cheam, he had demonstrated a talent for memorising excerpts from Shakespearian plays, and had felt at home on the stage. When a new English master, Eric Anderson, joined Gordonstoun in 1964, he encouraged the Prince to act in several Shakespeare dramas, casting him as the Duke of Exeter in *Henry V* and the lead in *Macbeth*.

Prince Charles' happiest time during his latter school years were the two terms spent, at his father's suggestion, at Timbertop in a remote part of Victoria, Australia. Charles felt liberated by the informality of a country where he was not judged on his royal heritage, and where students and masters treated him like one of them. He embraced the physical challenges with enthusiasm, undertaking cross-country expeditions of up to 70 miles in three days in relentless heat.

The Prince left Timbertop in July 1966; he returned to Gordonstoun for his final year that autumn and was appointed guardian (head boy). Having passed five O levels two years previously, he was now studying A levels, and received a B in history and a C in French.

Charles left Gordonstoun with a greater steeliness and strength of purpose, but determined to look at different education options for any children he might have.

GORDONSTOUN

Gordonstoun was founded by German educationalist Dr Kurt Hahn two years after he fled Nazi Germany in the 1930s. His vision was to create well-rounded citizens, focusing on life skills and service as much as academic achievement. As well as Prince Philip and Prince Charles, Prince Andrew and Prince Edward were also pupils there.

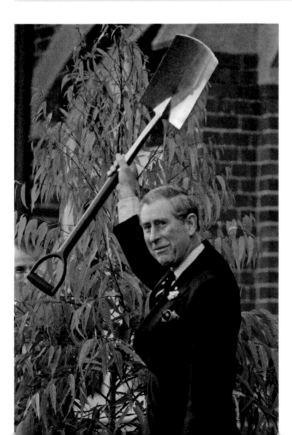

Prince Charles hoisted his spade aloft to acknowledge the students who cheered him on when, in 2005, he planted a tree at Geelong Grammar, around 50 miles west of Melbourne, in celebration of the school's 150th anniversary. The Australian school has always held a special place in Charles' heart since his time at its Timbertop campus in 1966, and he has returned to visit several times.

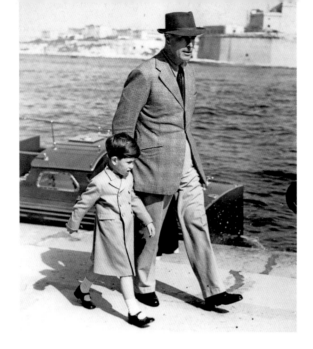

Close Relations

With less than two years separating them, Prince Charles and Princess Anne (later the Princess Royal), confined to a sheltered childhood in the nursery and schoolroom of Buckingham Palace and a regime led by nannies and governesses, were inevitably close as they grew up.

The children's paternal grandfather, Prince Andrew, the fourth son of King George I of Greece, had died in 1944 and their grandmother, Princess Alice of Battenberg, was mainly absent from their lives. Their son, Prince Philip of Greece, had led a disrupted childhood, having been forced into exile with his parents and sisters in late 1922. Princess Alice suffered from mental problems, which eventually led to a breakdown and her committal to a sanatorium. However, by the time Prince Charles was born she was recovered from her illness and living on the Greek island of Tinos, eventually becoming a nun. She wrote to Philip

'GAN-GAN'

Prince Charles' 'Gan-Gan' – his great-grandmother Queen Mary – died shortly before Queen Elizabeth II's Coronation. He had been the only great-grandchild permitted to touch the precious collection of jade objects that she kept in locked cabinets.

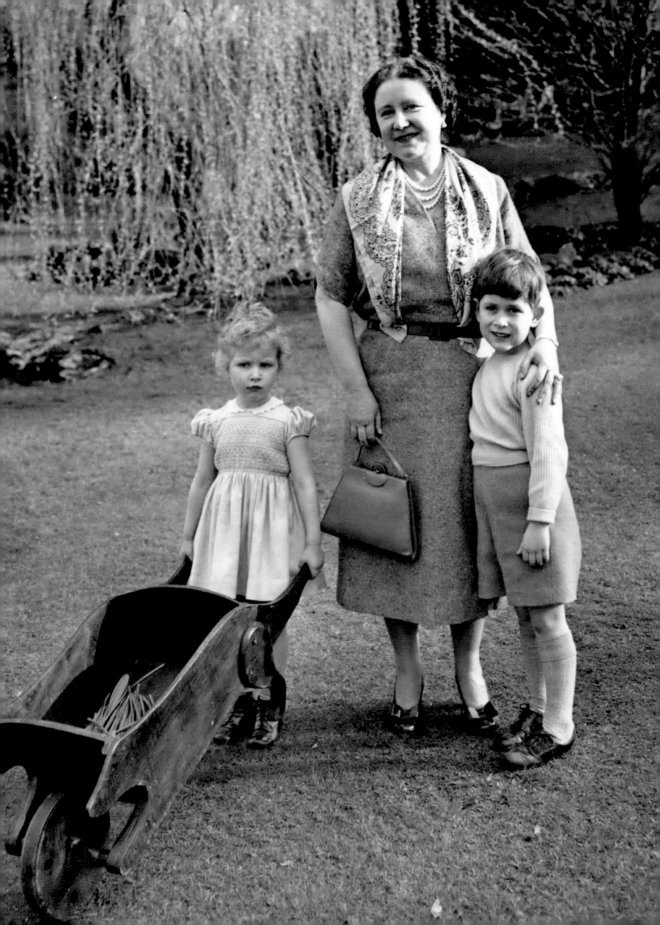

following the birth of his son: 'I think of you so much with a sweet baby of your own, of your joy and the interest you will take in all his little doings.'

Charles' closest relationship with a grandparent was with Queen Elizabeth the Queen Mother, who adored young children and was happy to indulge them. When his parents were away, Charles often visited her at Royal Lodge in Windsor Great Park. She gave the young boy hugs, encouraged his kind and gentle nature, and introduced him to a world of music and art. They remained close throughout her long life and when she died, aged 101, on 30 March 2002 – just seven weeks after her younger daughter, Princess Margaret – it was a huge loss for Charles. Although he had seen his grandmother just two days before he set off for a long-planned skiing trip to Klosters in Switzerland, he minded desperately that he was not with her when she died. Two days after her death, he gave a moving tribute, broadcast from his home at Highgrove, in which he spoke of his grandmother's 'utterly irresistible mischievousness of spirit'; he reflected on how she had served the British people with 'panache, style and unswerving dignity', and said how much he would miss her laugh and 'wonderful wisdom born of so much experience and of an innate sensitivity to life'.

Particularly in the early years of her daughter's reign, the Queen Mother had filled a gap when Charles and Anne's parents were absent; the new Queen worked tirelessly, her royal duties having to take precedence over her young family. Queen Elizabeth II had been settled in her role as monarch for more than seven years when it was announced that she was expecting another child. Prince Andrew Albert Christian Edward (later the Duke of York) was born on 19 February 1960. Four years later, on 10 March 1964, another son, The Queen and Duke of Edinburgh's last child, was born: Prince Edward Anthony Richard Louis (later the Earl of Wessex). The Queen was, by now, balancing work and family life and able to spend more time with her younger sons than she had her elder children. Prince Charles and Princess Anne were already teenagers by the time Edward arrived and took delight in their much younger siblings. Just as he had doted on Anne, Charles loved his young brothers and would spend hours playing with them.

One of the biggest influences on the young Prince Charles' life was the man he saw as 'the grandfather he never had' – his great-uncle Lord Louis Mountbatten, the younger brother of Prince Philip's mother. The Admiral of the Fleet, Earl Mountbatten of Burma was also an important part of Prince Philip's life.

A family photograph taken in the grounds of Frogmore House in Home Park, Windsor on 21 April 1965, Queen Elizabeth II's 39th birthday. Princess Anne supports her baby brother Prince Edward, as Her Majesty and Prince Charles look on; meanwhile the Duke of Edinburgh chats to five-year-old Prince Andrew.

Mountbatten had been present at the Royal Naval College in Dartmouth in late July 1939 when the 13-year-old Princess Elizabeth met for the first time the handsome 18-year-old Prince Philip, who was on a three-month officers' training course.

Prince Charles was a regular visitor to Broadlands, the Hampshire home of Mountbatten and his wife, Edwina. Uncle Dickie, as the young Prince called him, was affectionate towards his great-nephew; adept at balancing criticism with praise, the older man often acted as his confidant. When Mountbatten was killed by an IRA bomb as he piloted a boat out of the seaside village of Mullaghmore in County Sligo in Northern Ireland on 27 August 1979, the Prince was unable to imagine how he would 'come to terms with the magnitude of such a deep loss'. Charles read the lesson at Lord Mountbatten's funeral, and at a memorial service in St Paul's Cathedral gave a 25-minute address during which he was unable to suppress his anger at the murder of his uncle and the other innocent victims killed in the terrorist attack.

In May 2015, Prince Charles made a historic visit to the Republic of Ireland and Northern Ireland. Central to the trip was his pilgrimage to Mullaghmore where he met Timothy Knatchbull, who, with his parents, survived the 1979 IRA assassination that killed Timothy's twin brother, Nicholas. Nicholas died alongside Mountbatten and 15-year-old family friend Paul Maxwell. Timothy's grandmother, the Dowager Baroness Brabourne, had died of her injuries the following day. Prince Charles expressed his hope that Britain and Ireland could forge 'a lasting legacy of peace, forgiveness and friendship' for future generations.

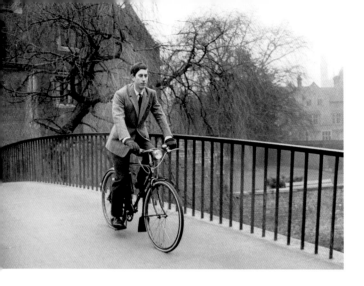

LEFT: The student Prince: Charles cycling in Cambridge.

OPPOSITE: Prince Charles graduated from Cambridge with a 2:2 in 1970, the first heir apparent to earn a university degree. He is seen here leaving Senate House, Cambridge in 1975, having subsequently been awarded a Master of Arts degree.

University Years

Prince Charles was the first heir to the throne to be enrolled for a university degree. The chosen university – Cambridge – was agreeable to the young man who admired its architectural glory and revered traditions. Another plus was its close proximity to the royal Sandringham Estate in Norfolk where he could indulge his passion for pheasant shoots and enjoy the comfort of Wood Farm farmhouse, which his mother permitted him to use, with its views looking out over the marshes to the North Sea.

Charles arrived at Trinity College, Cambridge in October 1967. A trip to Papua New Guinea while he was a student at Timbertop in Australia had stimulated an anthropological interest and in a show of independence he rejected the course of study chosen for him as future monarch, settling instead on one that combined anthropology and archaeology. He believed studying anthropology would prepare him for kingship, saying: 'If more people can be assisted to appreciate and understand their own social behaviour, the better and more healthy our society will be.'

The Prince's living quarters included accommodation for his detective and official equerry. Like all students, whatever their status, he was assigned a 'bedder' who would make his bed, tidy his room and serve him tea; unlike other students, though, Charles had the privilege of his own bathroom.

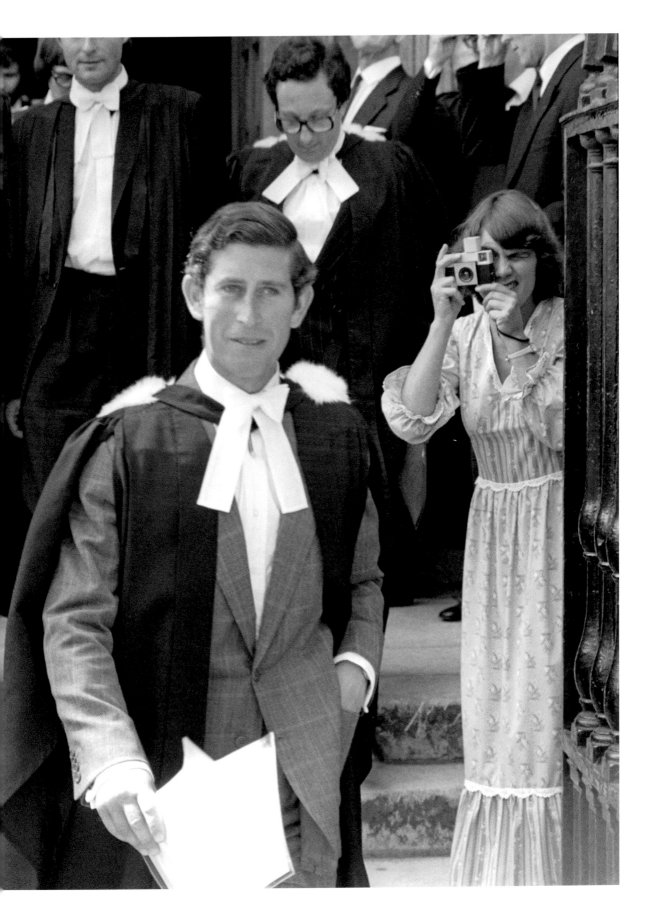

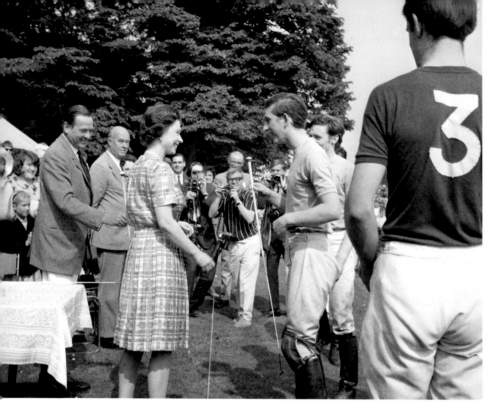

In 1968, after playing in the annual Varsity Polo Match between Oxford and Cambridge, which Oxford won that year, Prince Charles was presented with a riding crop by his mother, The Queen.

Just as at Cheam and Gordonstoun, the characteristically shy Charles did not always find it easy to make friends among his peers and instead found camaraderie outside the student body in the world of hunting and shooting that he knew and loved. Despite this being the 'Swinging Sixties', he preferred to dress in the clothes in which he felt most comfortable: corduroy trousers and tweed jackets. With his hair neatly trimmed, he took pride in his conventional image and was 'happy to be square'.

Charles was taking a keen interest in religion, influenced by the Reverend Harry Williams, Dean of Chapel at Trinity, who introduced him to the works of Carl Jung and Sigmund Freud. Although Williams' teachings shocked fundamentalists, he and Charles dined together regularly, enjoying discussions that pushed the boundaries of traditional theology, and he said the Prince had 'the grace, the humility and the desire to help other people'.

Prince Charles also enjoyed the lighter side of life at Cambridge, playing polo in university colours and also continuing his enjoyment of acting. In November 1968, he joining Trinity's drama group, the Dryden Society. Among other roles, he was cast in a comedy revue as a cleric and took a similar part in *The Erpingham Camp*, a dark comedy by Joe Orton.

A KEEN SENSE OF HUMOUR

King Charles has long been known for his sense of humour and for taking pleasure in alternative comedy. As a child, a favourite book had been Hilaire Belloc's *Cautionary Tales for Children*, full of quirky characters. He was a big fan of *The Goon Show*, a satirical BBC radio programme which began in the 1950s and ended in 1960. During his time at Timbertop in the 1960s, Charles was known for his clever mimicry of its characters – in particular Peter Sellers' 'Bluebottle'. The Prince later became honorary president of the Goon Show Preservation Society.

The Prince was, nevertheless, mindful of his future role, and in his second year he also studied history, including British constitution. He was a conscientious student, considered talented by Master of Trinity Richard 'Rab' Butler, and his Director of Studies reported that the student Prince wrote 'useful and thoughtful essays … he is interested in discussion and likes to draw parallels between the people we study and ourselves'. Charles graduated on 23 June 1970 with a 2:2.

Spike Milligan – who along with Harry Secombe, Peter Sellers and, at one time, Michael Bentine, starred in *The Goon Show* – receives an Honorary Knighthood from Charles, Prince of Wales in 2002.

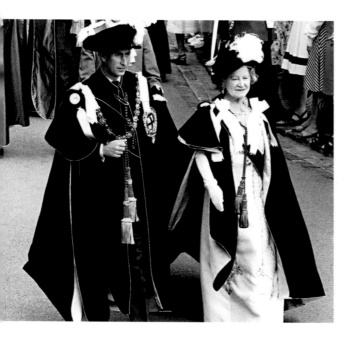

Becoming Prince of Wales

'And him Our most dear Son Charles Philip Arthur George as has been accustomed. We do ennoble and invest with the said Principality and Earldom by girting him with a Sword by putting a Coronet on his head and a Gold Ring on his finger and also by delivering a Gold Rod in his hand.'

With these noble words of the Letters Patent, The Queen created her son Prince of Wales in 1969. It was 11 years earlier, when Prince Charles was watching the closing ceremony of the Commonwealth Games (taking place in Cardiff that year) on television with some school chums in the headmaster's study at Cheam, that he heard his mother declare in a recorded speech that he was to become the Prince of Wales. Attached to his new Welsh title would be yet another: Earl of Chester.

Two weeks after the announcement, and en route to Scotland with his parents on the royal yacht *Britannia*, Charles visited Anglesey where he was warmly welcomed. But the boy was still only nine years old and it would be several years before he was invested as the 21st Prince of Wales.

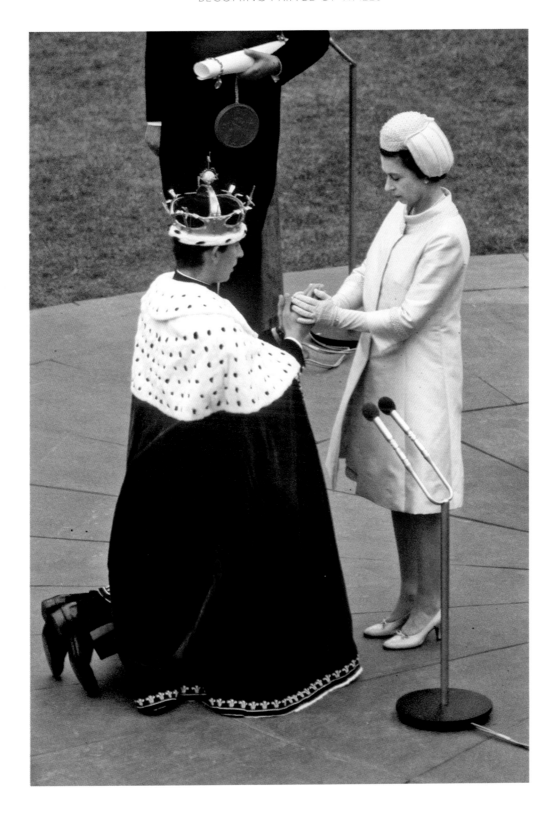

The investiture was two years in the planning and to take place on 1 July 1969, a few months before Prince Charles turned 21. A full year before, on 17 June 1968 Prince Charles was invested and installed as a Knight of the Garter at St George's Chapel, Windsor.

The venue for his investiture as Prince of Wales was to be the medieval Caernarfon Castle in North Wales, founded by King Edward I and where his son, Edward, the first Prince of Wales, was born in 1284. In preparation for the ceremony, Charles was enrolled for a nine-week term at the University College of Wales at Aberystwyth, which exposed him to the Principality's language, history, culture and traditions. Several weeks before the end of term, he made his first speech in Welsh at a youth festival for poetry, drama and music, which earned him a standing ovation. In the lead-up to the investiture, the British public heard Prince Charles' voice – many for the first time – in a series of interviews on radio and television in which he came across as engaging, self-effacing and articulate.

Although the day of the investiture dawned overcast, the weather could not deter from the thrill of the pomp and ceremony of the occasion. The Letters Patent, read by The Queen, and the insignia – the sword, coronet, mantle, gold ring and gold rod – were central to the ceremony. After Her Majesty had placed the jewelled coronet on Prince Charles' head to crown him Prince of Wales, she smoothed the mantle of purple velvet trimmed with ermine around his shoulders with a motherly touch. He then paid homage to her, which he later recalled as

PRINCE OF WALES' FEATHERS

There was much honour, ceremony and symbolism attached to Charles as Prince of Wales, including various titles, a coat of arms, Royal Standards and the granting of Royal Warrants. The symbol of the Prince of Wales' feathers is instantly recognisable and was first used in the 14th century by the second Prince of Wales, better known as the Black Prince. The badge comprises three feathers rising behind a gold coronet decorated with crosses and fleur-de-lys, and the motto *Ich Dien* (I serve) is depicted on dark blue ribbon. There are various theories about how the symbol and motto came into being: one suggests the feathers were used by the family of the Black Prince's mother, Philippa of Hainault, and that the motto formed part of the arms of the King of Bohemia.

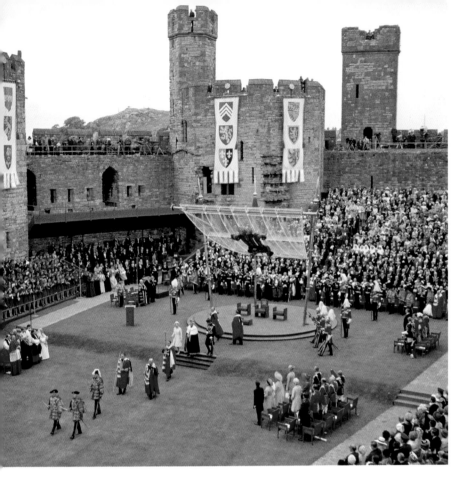

A bird's-eye view of Prince Charles' investiture as Prince of Wales at Caernarfon Castle.

being the most moving moment for him: as The Queen placed her hands between his, he declared to be her 'liege man of life and limb and of earthly worship … to live and die against all manner of folks'.

The investiture had been tailored for broadcast on colour television – still a fairly new phenomenon in Britain – under the direction of Lord Snowdon, Charles' uncle and the husband of Princess Margaret. What was seen as Prince Charles' official 'coming of age' was watched by 500 million people worldwide. The young man carried off the whole event with great composure, including speeches that he made in both English and Welsh, which were followed by a short religious service. In the meantime, throughout the country children were enjoying street parties in celebration of the occasion. Following his investiture, the Prince made a three-day tour of Wales, and was touched by the support of the Welsh people everywhere he went.

Now that Charles is King, we have, of course, a new Prince of Wales: his son, Prince William.

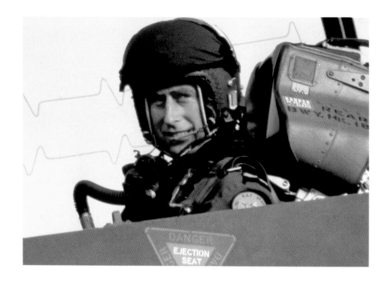

A Career in the Armed Forces

The Duke of Edinburgh and Lord Mountbatten were keen for Prince Charles to follow in their footsteps – and those of both of Charles' great-grandfathers – by attending the Royal Naval College, Dartmouth and serving as a naval officer.

However, in March 1971 the Prince of Wales first started his military career at RAF Cranwell in Lincolnshire. A year's training was compressed into five months, and he applied himself well to every task. He had already taken flying lessons

THE PRINCE AND THE PARACHUTE

In July 1971, during his time in the RAF, Prince Charles made his first parachute jump – and it could easily have ended in tragedy. He had no hesitation in jumping from the plane when his turn came – but as he tumbled out of the slipstream and his parachute opened he found himself upside down, his feet tangled in the rigging. He kept calm and was able to untangle himself before touching down on the waters of Studland Bay in Dorset. After the experience, he joked that he had only had a 'short time to admire the view'.

Six years later he enlisted on a parachute course after being appointed Colonel-in-Chief of the Parachute Regiment, saying: 'I didn't think I could look them in the eye or indeed ever dream of wearing the beret with the Parachute Regiment badge unless I'd done the course.'

Prince Charles, as Colonel-in-Chief of the Parachute Regiment, chats to a young recruit at the Airborne Forces Day parade in Aldershot, Hampshire in 1978.

during his second year at Cambridge and had flown solo for the first time in 1969, so learning to fly jets was a natural progression and one that he loved. He received his wings on 20 August 1971, having enjoyed his time among officers and gentlemen who had made him feel so welcome.

Charles started at the Royal Naval College, Dartmouth the following month. Again, his training was condensed, this time from the customary three months to six weeks. He flew to Gibraltar on 5 November to join the destroyer HMS *Norfolk*, spending seven months at sea living in a small cabin. From May 1972 he spent six months on land studying at various naval schools before setting off in January 1973 on HMS *Minerva*, a smaller destroyer with fewer officers, which meant greater responsibilities for junior naval officer Prince Charles.

January 1974 saw him join HMS *Jupiter* in Singapore as the ship's communication officer. He was also in charge of 15 non-commissioned officers. During his time at Timbertop in Australia, the headmaster Thomas Garnett had reported that Charles proved an admirable leader when put in charge of younger students; his role on *Jupiter* played to this strength and he handled his men's professional and personal problems extremely well.

In July of that year, the Prince was frustrated when the Ministry of Defence decided against sending him into a war zone when conflict broke out between Greece and Turkey. However, he was granted permission to train as a helicopter pilot that autumn and told that he could join the commando carrier HMS *Hermes* to fly helicopters in spring 1975. A keen pilot and a quick learner, he became a

qualified helicopter pilot in December 1974, and left England for HMS *Hermes* the following March.

For Prince Charles' final tour of duty in the Royal Navy, he was given command of coastal minesweeper HMS *Bronington* in February 1976. Once more his people skills came to the fore and morale was high among his men. When he left the Navy in December that year, he had attained an 'excellent level of professional competence'.

King Charles III has been involved with the military ever since. As King of the United Kingdom, he now serves as the head of the British Armed Forces. On the death of his mother, he was promoted to the rank of Admiral in the Royal Navy, General in the Army and Air Chief Marshal in the RAF. Although his medals aren't for active service in combat, he is still highly decorated for serving at a particular time or place, being a member of high-ranking order and through receiving medals from other countries. And having served for five years gives him credence when he wears the uniforms of regiments around the world that he oversees.

The Queen, Lord High Admiral of the United Kingdom 1964–2011, being piped aboard HMS *Bronington*. She was visiting the ship's commander, her son Prince Charles (far right), on his 28th birthday.

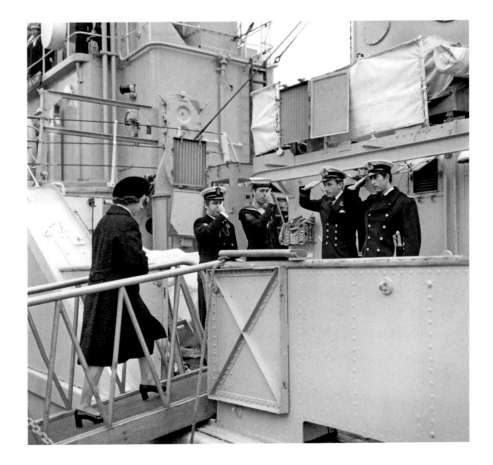

A Young Royal Ambassador

As he approached his 21st birthday, Prince Charles was asked to describe the moment he first realised he was heir to the throne. He responded: 'I think it's something that dawns on you with the most ghastly inexorable sense ... and slowly you get the idea that you have a certain duty and responsibility.'

Even as a child, Charles had lived with the knowledge of duty and obligation that comes with the territory of being heir apparent. Soon after his 18th birthday, the Prince was named Counsellor of State. Other Counsellors of State at that time included the Duke of Edinburgh, the Queen Mother, Princess Margaret and Prince Henry, Duke of Gloucester. It was a role that empowered Charles to act on The Queen's behalf when she was out of country and would enable him to become Prince Regent if she became incapacitated.

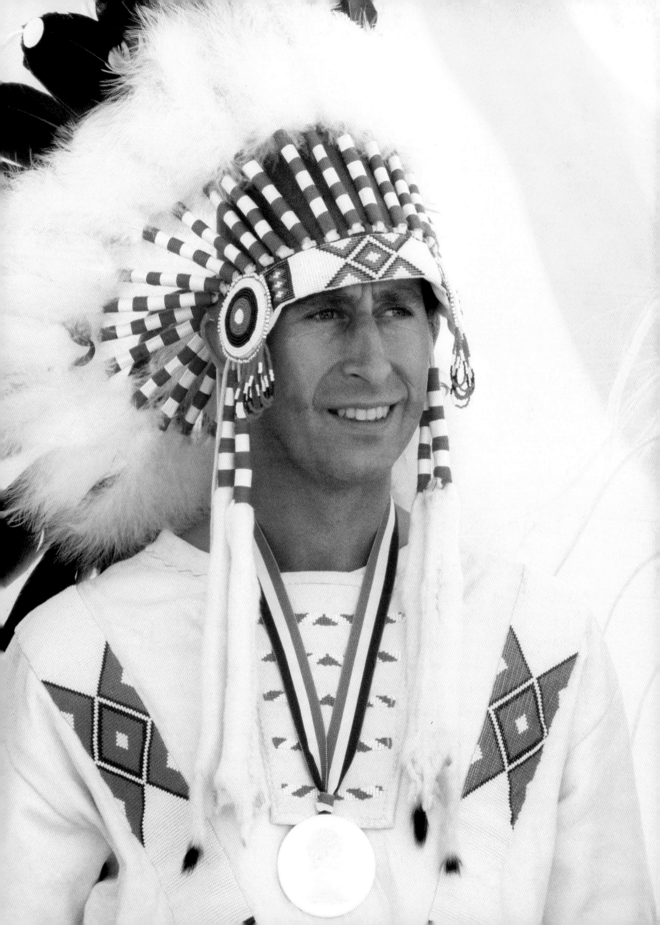

COUNSELLORS OF STATE

The duties of Counsellors of State are to carry out most official duties of the monarch, including attending Privy Council meetings, signing routine documents and receiving the credentials of new ambassadors to the United Kingdom. There are certain constitutional functions that cannot be delegated: Commonwealth matters; the dissolving of Parliament, except at the monarch's express instruction; appointing a Prime Minister; the creation of peers.

The law requires that Counsellors of State include the sovereign's spouse and the next four people in the royal line of succession who are over the age of 21 (or 18 if an heir apparent or heir presumptive). When Prince Charles ascended the throne as King Charles III in September 2022, the Counsellors of State were his Queen Consort, Prince William, Prince Harry, Prince Andrew and Princess Beatrice.

Shortly after going up to Cambridge, in October 1967 Charles attended his first State Opening of Parliament, presided over by his mother. Two months later he represented The Queen for the first time overseas at the funeral of the Prime Minister of Australia, Harold Holt. It was a country that Charles felt a great affinity with since his time at Timbertop when he had attended around 50 official engagements, his first solo experience of representing the Royal Family in this way. That first Australian experience had given the shy young man confidence to take the plunge and engage with people; it turned out to be a very positive experience, which he said 'suddenly unlocked a completely different feeling, and I was then able to communicate and talk to people so much more'. That new-found confidence was perhaps even more remarkable as, other than his time at Timbertop, it was one of few occasions that he'd left Europe, his first being aged five when he and Princess Anne had travelled to Libya and Malta at the end of their parents' Commonwealth tour in 1954.

Summer 1968 saw Charles making his inaugural official foreign visit to Malta. He also spent time shadowing public service employees at several government departments in London to gain an understanding of their jobs.

The Prince of Wales was taken out of university for four weeks in the spring of 1970 for a royal tour of Australia, Hong Kong, New Zealand and Japan, his route taking him to the USA for the first time. In July that year, he and Princess

Anne took centre stage on a three-day visit to the White House as guests of President Nixon. In October 1970, Prince Charles represented The Queen at the independence celebrations in the former British colony of Fiji, where he admired the gentle people who had 'the most perfect and touching manners and the greatest dignity and humour I have ever seen'.

The Prince was, therefore, already a talented diplomat and familiar with performing royal duties when he made the transition into civilian life in 1977, The Queen's Silver Jubilee year. He had a strong desire to shape his life into one that would be fulfilling while he bided his time until he acceded the throne. Shortly before his 30th birthday in November 1978, during a lecture at Cambridge Union Society he revealed, 'My great problem in life is that I do not really know what my role in life is. At the moment I do not have one. But somehow I must find one.'

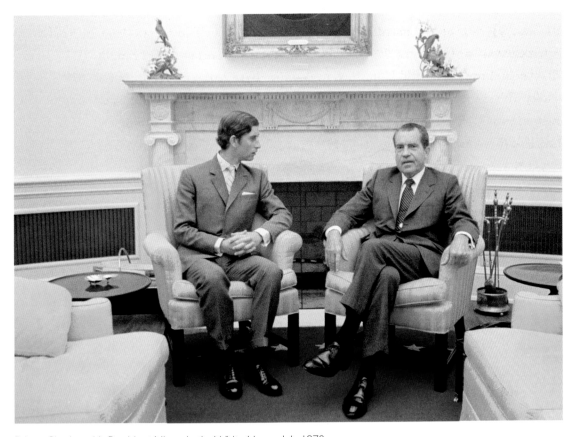

Prince Charles with President Nixon in the White House, July 1970.

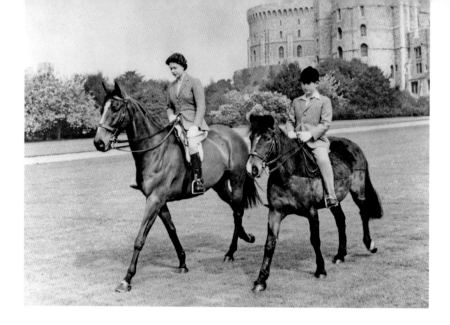

LEFT: Mother and son: Queen Elizabeth II and Prince Charles riding at Windsor in 1961.

OPPOSITE: Father and son: Prince Charles and Prince Harry at Cirencester Park Polo Club, Gloucestershire in 2005.

Sports and Pastimes

Queen Elizabeth II always had a passion for everything equestrian, and it was she who taught Prince Charles to ride when he was four. Although initially timid on horseback, he was soon at home in the saddle, although – unlike his bolder sister – he feared jumping. This was an anxiety he overcame in the mid-1970s when, having decided he wanted to hunt, he took lessons – including from Princess Anne. Charles first hunted at Badminton with the Beaufort Hunt in February 1975 and was immediately hooked.

Eager to follow his father's lead, the Prince took up polo at the age of 12. By 1964, under the Duke of Edinburgh's watchful eye, the teenager was applying himself well to the sport. When Charles joined the polo team at the University of Cambridge a few years later, he proved to be a tough and passionate player. He competed at the highest level and won a half blue, notably a sign of success at county or regional level.

It was the Duke of Edinburgh who taught a young Prince Charles to swim, shoot and fish, and the latter in particular was a pastime he enjoyed with his grandmother. Charles also became a competent sailor as a youngster, regularly taking to the water at Cowes with his father's friend, the boat designer and sailing enthusiast Uffa Fox.

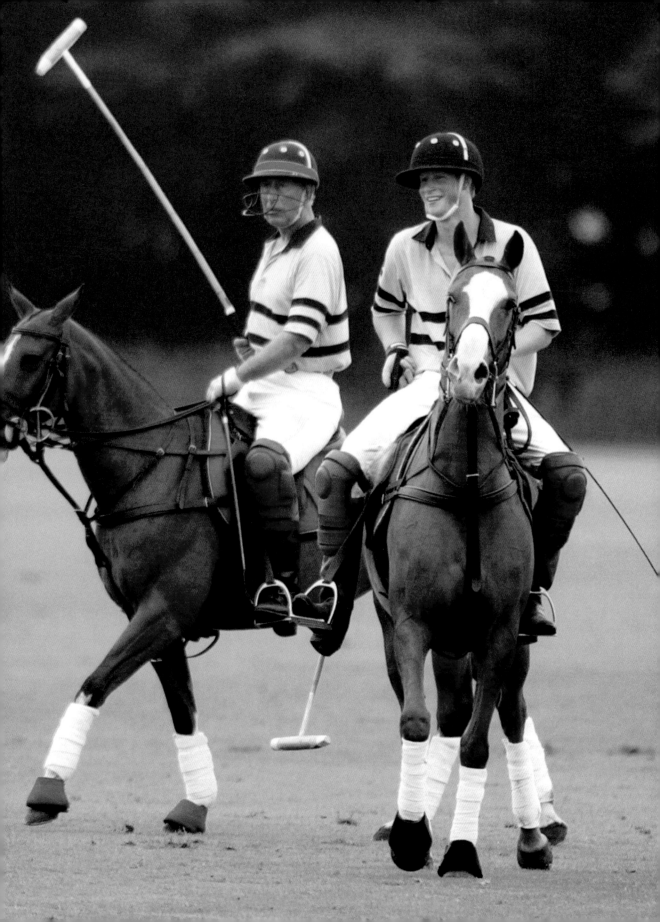

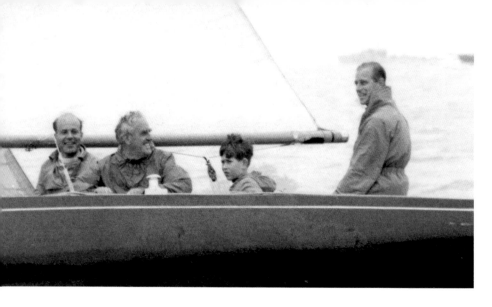

Prince Charles sailing on the Solent with his father and Uffa Fox (second left) during Cowes Week, August 1958. The famous Isle of Wight regatta was started by King George IV, himself a keen yachtsman, in 1826.

In early 1977, the Prince of Wales added to his sporting prowess during his first stay at Klosters in Switzerland at the invitation of friends Charlie and Patti Palmer-Tomkinson. Just as he rode ponies to the limit on the polo field and horses in the same way when hunting, he proved to be fearless on the ski slopes and was soon skiing off-piste. An annual trip to Klosters quickly became a regular fixture on the royal calendar.

The Hunting Act 2004 came into effect on 18 February 2005 and the previous day Prince Charles had ridden out with the hunt for the last time. It was the same year that he hung up his polo mallet. Polo had been an important part of his psychological and physical wellbeing for many decades. It was a sport he

TRAGEDY AT KLOSTERS

In 1988, a terrible skiing incident nearly cost Prince Charles his life. He was enjoying a holiday at Klosters with family and friends – including the Palmer-Tomkinsons and Major Hugh Lindsay, former equerry to The Queen – when some of the party decided to go for one final run of the day, led by local guide Bruno Sprecher. No one could have predicted the events that were to follow. An avalanche hurtled down the mountain; Sprecher shouted 'Jump!' and Prince Charles and Charlie Palmer-Tomkinson made it onto a ledge next to the rock face, but the wall of snow swept Hugh Lindsay and Patti Palmer-Tomkinson over the edge. Patti was critically injured but Hugh Lindsay was killed. His wife gave birth to their first child two months later, and, when many shied away, Prince Charles made sure he was available to her and encouraged her to talk of her husband as often as she wanted and needed to.

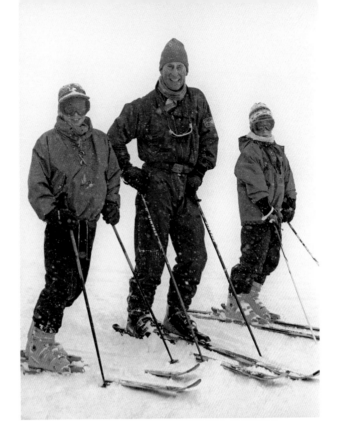

Prince Charles and his sons on the ski slopes at Klosters in 1995.

enjoyed with his children and, despite his advisors trying to persuade him to retire after numerous bones had been broken, it was not until 2005 when his back was proving too painful to continue that he made the decision for himself, handing over his polo ponies to his sons. Both Prince William and Prince Harry have continued the royal tradition of fund-raising through charity polo matches.

Now in his 70s, King Charles III still participates in shooting and hiking with a vigour that can leave much younger friends and family members trailing in his wake. Queen Elizabeth II loved dogs, and her eldest son is equally fond of his canine companions; one is rarely far from his heel when he is out in the countryside.

But despite what was often seen as a 'man of action' image, out of the sporting arena Charles has always demonstrated a love of more gentle pursuits. During the summer before his final year at Cambridge, he wrote his first book while on holiday with his family in the Western Isles aboard the royal yacht *Britannia*. It was a story he invented to entertain his young brothers, Andrew and Edward, which tells of an old man who lives in a cave under Lochnagar, a mountain overlooking the royal estate at Balmoral. *The Old Man of Lochnagar* was published more than a decade later in aid of one of Charles' charities, The Prince's Trust.

As an artist, King Charles – seen here with one of his watercolours of the Castle of Mey – uses the name A.G. Carrick. The pseudonym was formed from two of his Christian names – Arthur and George – and one of the titles he held before becoming King: the Earl of Carrick. That title is held by the heir apparent, so in September 2022 it passed to Prince William.

It was the Queen Mother who instilled and encouraged Charles' love and talent for art, a subject for which he was praised in school reports. Between leaving university and taking up his career in the armed forces, he took up watercolour painting and was further encouraged in his artistic endeavours by his father, who was a keen oil painter.

King Charles greatly admires the work of 18th-century artist J.M.W. Turner. Landscapes became his preferred medium as an outlet for creative expression and he was 'exhilarated at being transported into another dimension' with his pictures that display a delicate intimacy, coupled with a sense of melancholy. Although he enjoys painting in the open air, it is not always possible, so he makes a habit of drawing rough sketches and making notes about the colours, the light and so forth, then paints the landscape in his studio, when his busy schedule allows. A gratifying personal achievement has been the commercial success of his artworks, which have raised millions of pounds for his charities.

It was also his grandmother who instilled a love of music in the young Charles. Although classical music may have been common ground between them, rock and pop music have long been an important part of the King's life. Many famous stars of the music industry have supported The Prince's Trust over the years; the first benefit gig for the charity took place in London in 1982. With such names as Pete Townshend, Phil Collins, Jethro Tull and Kate Bush headlining, it was a sell-out.

With music, of course, comes dancing, and Charles has always been an enthusiastic and uncharacteristically uninhibited dancer. He had private lessons from Madame Betty Vacani at Buckingham Palace and prides himself on his prowess on the ballroom floor.

In 1988 Prince Charles chose to mark his 40th birthday by celebrating with 1,500 young people who had been helped by The Prince's Trust. At this daytime party, he danced with several of the partygoers, one of whom said, 'He dances well for an old man!' That evening a black tie ball for 300 guests was hosted in their son's honour by The Queen and Prince Philip at Buckingham Palace. After the formalities, two rooms were set aside for dancing – one ballroom, the other disco.

The Queen Mother loved to hold parties at Birkhall on the Balmoral Estate. These would often involve dancing Scottish reels in which she encouraged a young Prince Charles to participate with eligible debutantes. In September 2001, six months before she died, Charles had cancelled a holiday to fly to Birkhall to join his grandmother. Although she had turned 101 the previous month, one evening she felt perky enough to dance a Highland reel. Nevertheless, as her biographer William Shawcross observed, 'there was an elegiac note' to her mood and her grandson knew he faced the unspoken reality of her final decline.

Prince Charles partnered a young woman on the dance floor at one of the parties to celebrate his 40th birthday. This particular celebration was held at the Aston Manor Road Transport Museum in Birmingham, transformed from a derelict tram shed, which he had formally opened that day.

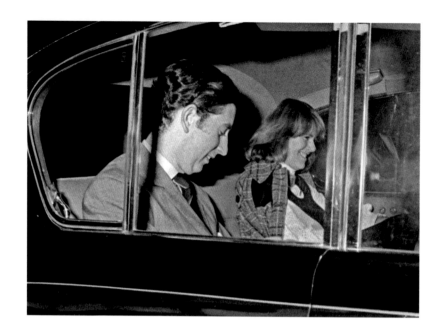

An Eligible Bachelor

The heir to the throne was an eminently eligible bachelor and the tabloids had a field day speculating on any young lady who appeared to catch his eye. Among them, but not exclusively so, were members of the aristocracy.

At university in 1969, Rab Butler introduced Charles to Lucia Santa Cruz, daughter of the Chilean ambassador to Britain. She was working for the Master of Trinity as a research assistant on his memoirs. It has been claimed that she was the 'first love of his [Charles'] life', but a permanent relationship was out of the question: Lucia was Roman Catholic and the heir to the throne was, at that time, required by law to marry a Protestant. However, to this day they remain good friends, and it was she who first introduced him to the woman who was to have a huge impact on his life: Camilla Shand.

It is a popular misconception that Charles and Camilla first met at a polo match at Smith's Lawn; they met in the summer of 1972 through their mutual friend Lucia Santa Cruz who lived in the same block of flats as Camilla. Charles, who was between postings on HMS *Norfolk* and HMS *Minerva*, was immediately smitten by the warm, unassuming 25-year-old who shared his love of the countryside, his sense of humour and his indifference to the latest fashions.

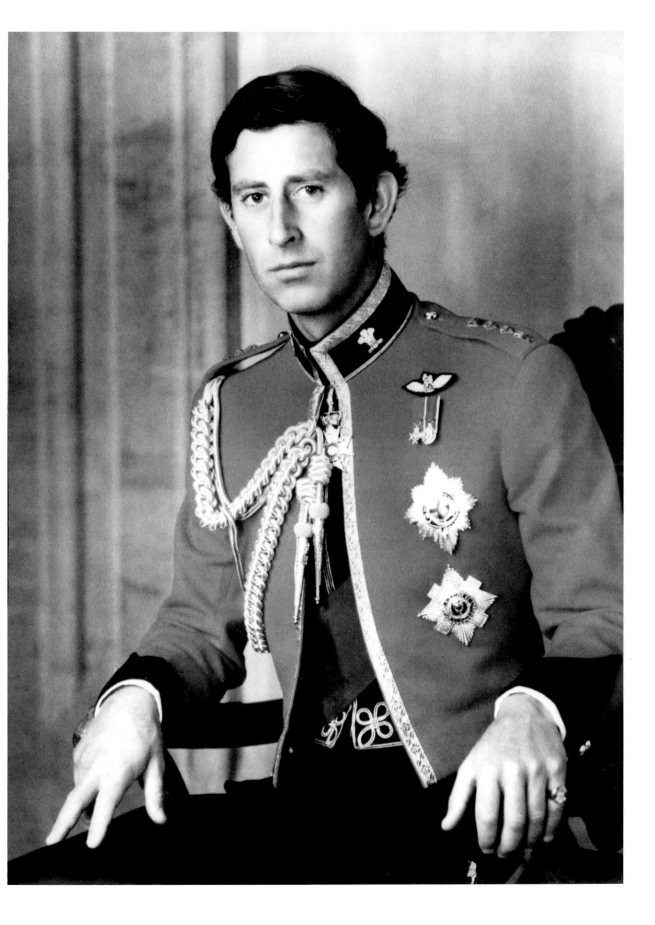

A ROYAL WEDDING

When Princess Anne married Captain Mark Phillips in November 1973, there was a fresh round of conjecture about her elder brother's marriage prospects. At that time the press was paying close attention to Charles' relationship with Lady Jane Wellesley, the 22-year-old daughter of the Duke of Wellington, but any romance there may have been fizzled out.

Despite their mutual attraction, Prince Charles was still only 24 and not yet ready to settle down. Camilla was in a long-term on-off relationship with the handsome Andrew Parker Bowles, a one-time boyfriend of Princess Anne. Charles and Camilla became the greatest of friends and on hearing the news of her engagement to Parker Bowles in March 1973, the Prince, on board HMS *Minerva* in the Caribbean, was bereft. Charles did not attend Andrew and Camilla's wedding four months later, claiming he was duty-bound to attend Independence Day celebrations elsewhere, but he was godfather to their first child, Tom.

The Queen's Procession arrives in Westminster Abbey for the wedding of Princess Anne and Captain Mark Phillips on 14 November 1973. The uniformed Prince of Wales walks behind his mother and grandmother and beside his brother, Prince Andrew. The wedding took place on Prince Charles' 25th birthday and fuelled speculation about who would one day be his bride.

The handsome young Prince Charles inspecting troops in Papua New Guinea in 1975, the year it became an independent Commonwealth realm with Queen Elizabeth II as its sovereign. Charles was there to represent his mother at the ceremony and celebrations held in Port Moresby.

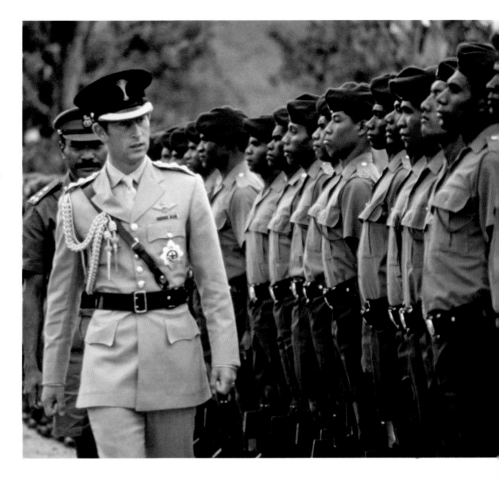

'Uncle Dickie' thought his granddaughter Amanda Knatchbull would make Charles the perfect wife; she fitted Mountbatten's recommendation that the Prince find a 'suitable and sweet charactered girl before she met anyone else she might fall for'. But as second cousins they had known each other since childhood, and a long-term romance was not to be.

In June 1977 he met Lady Sarah Spencer, daughter of the 8th Earl Spencer, at a house party at Windsor Castle. Charles was invited to Sarah's home, Althorp in Northamptonshire, where he first met her younger sister, 16-year-old Diana. Both girls were invited to the Prince's 30th birthday party at Buckingham Palace the following year.

Despite rising pressure on Prince Charles to choose a bride, he was increasingly concerned that whoever he married would suffer 'an immense sacrifice and a great loss of freedom'.

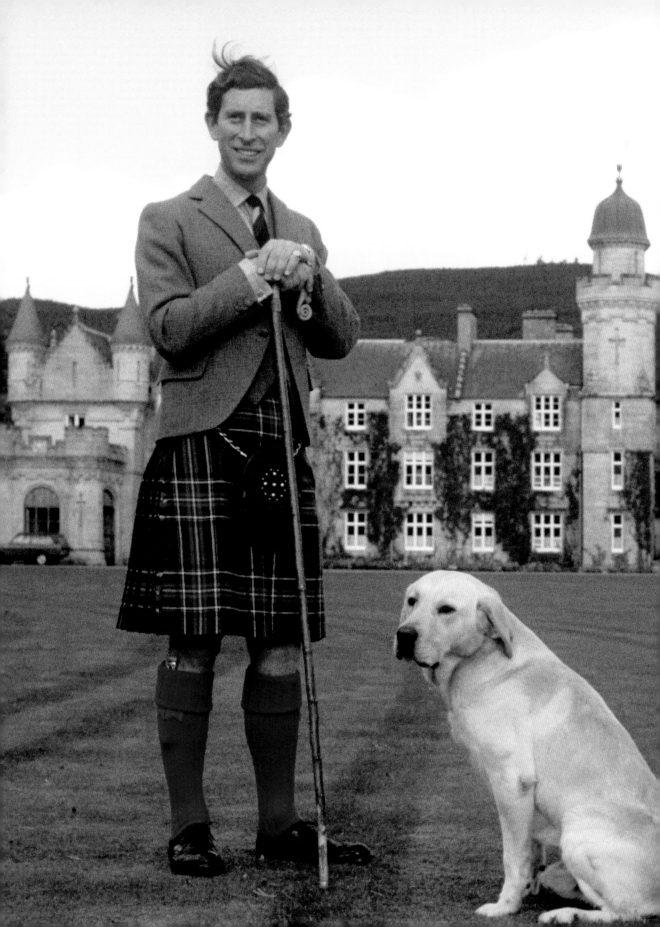

Prince Charles,
photographed shortly
before his 30th birthday,
with his Labrador, Harvey,
at Balmoral. The Prince is
wearing a kilt of Hunting
Stewart tartan which once
belonged to his grandfather,
King George VI.

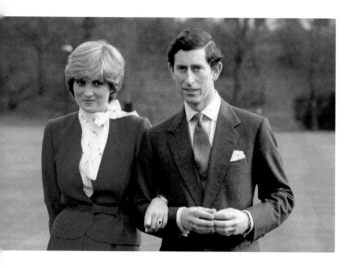

Diana, Princess of Wales

Lady Diana Spencer matched perfectly Lord Mountbatten's vision for Charles to take as a bride a 'sweet charactered girl' without a romantic past.

The Prince's romance with Diana started at Balmoral in the summer of 1980. He was on holiday and she was helping to care for the newborn child of her sister Jane, who was married to Robert Fellowes, assistant private secretary to The Queen. Her Majesty approved of Charles' friendship with 19-year-old Diana, inviting her to the Braemar Gathering that autumn.

The press was soon hounding demure 'shy Di', as they nicknamed Diana, and the world speculated about whether the Prince of Wales would propose to this young woman, who at the time was working as a kindergarten assistant.

Despite their short courtship and his uncertainty about their relationship, Prince Charles asked Lady Diana for her hand and their engagement was announced in February 1981. Diana's life changed immediately. Having enjoyed the freedom of flat-sharing with friends in London, she was moved to royal quarters to protect her from the spotlight as wedding plans took shape and she was instructed in the demanding duties expected of a future Queen.

The nation was whipped into a frenzy of excitement for the royal wedding that took place on 29 July 1981 at St Paul's Cathedral.

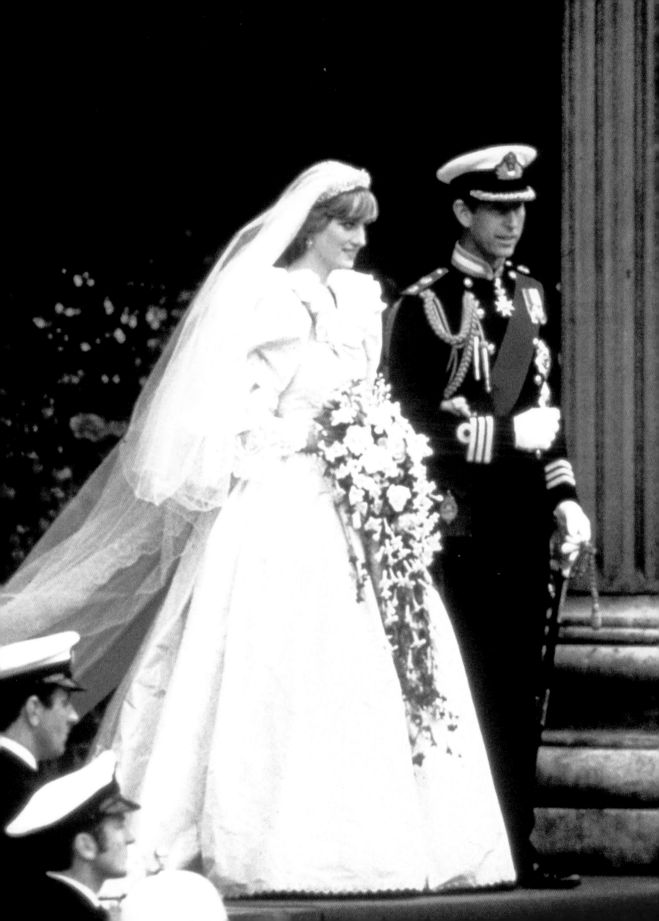

A SPECIAL MEMENTO

Prince Charles wanted a special memento of his and Diana's wedding, and commissioned watercolour artist John Ward to sit in the choir of St Paul's Cathedral and create a painting of the ceremony.

There were 2,500 wedding guests at St Paul's. The groom wore the full-dress uniform of a naval commander and the bride a beautiful ivory silk taffeta gown designed by David and Elizabeth Emanuel. The televised wedding ceremony was seen around the world by 750 million people. Back at Buckingham Palace for the wedding breakfast, the Royal Family made its customary appearance on the balcony and the crowds cheered when Charles kissed the new Princess of Wales. Later, an open landau carried them to Waterloo Station and they travelled to Broadlands in Hampshire to begin their honeymoon, just as Charles' parents had done nearly 34 years earlier.

That Charles and Diana's marriage ended unhappily has been well documented. However, what has never been in doubt is the joy that the birth of their two sons, Prince William and Prince Harry, brought the couple, and these blessings that their union brought cannot be denied.

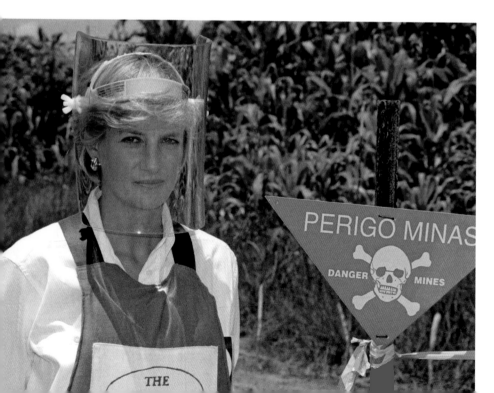

Diana, Princess of Wales was well known for her humanitarian work. She campaigned for the worldwide banning of landmines and is seen here touring a minefield in Angola in January 1997.

Prince Charles accompanied the coffin bearing Diana, Princess of Wales on the aircraft which flew from Paris to RAF Northolt in west London. Her coffin, draped in the Royal Standard, was carried in a slow march across the tarmac by airmen of the Royal Air Force. The nation was united in grief for the Princess's royal ceremonial funeral, which took place on 6 September 1997.

When Prime Minister John Major announced the Prince and Princess of Wales' separation in December 1992, the couple's united message was that they were both intent on continuing to provide 'a happy and secure upbringing' for their sons.

Charles and Diana had been divorced for just a year when she was killed in a car crash in Paris on 31 August 1997. Despite their differences, Charles still held Diana in deep affection. Distressed beyond belief and worried about his sons, he flew to Paris, accompanied by the Princess's sisters, Sarah and Jane, to bring her body home.

The Queen, at Balmoral when news of Diana's death broke, was criticised by the media for not making an official announcement or returning to London immediately. However, Her Majesty's priority was her grandsons, and she consoled them in private. Above all she wanted to protect them from the public eye for as long as possible.

Following the funeral, Diana, Princess of Wales was laid to rest on an island at her family home, the Althorp Estate in Northamptonshire.

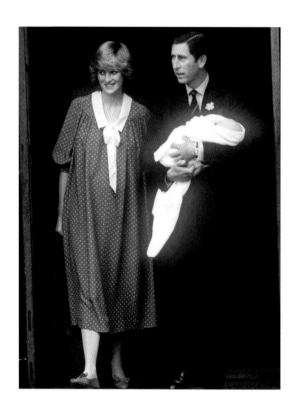

Prince William

In October 1981, just three months after their wedding, the Prince and Princess of Wales were overjoyed to learn that she was pregnant with their first child. 'Baby Wales' was born on 21 June 1982, the first future monarch to be delivered in hospital rather than a royal palace. Well-wishers and journalists gathered outside St Mary's Hospital, Paddington when, two days later, the 33-year-old Prince of Wales and his wife – still eight days shy of her 21st birthday – introduced their baby to the world. Before the family drove home to Kensington Palace, Prince Charles spoke of the pleasure the birth of their son had given him and Diana, adding, 'It has made me incredibly proud and somewhat amazed.'

Prince William Arthur Philip Louis of Wales was christened on 4 August. Charles and Diana were hands-on parents, and Charles made sure he spent as much time as he could with his son. In a break with royal tradition, when Charles and Diana travelled to Australia for a royal tour the following spring, William went with them.

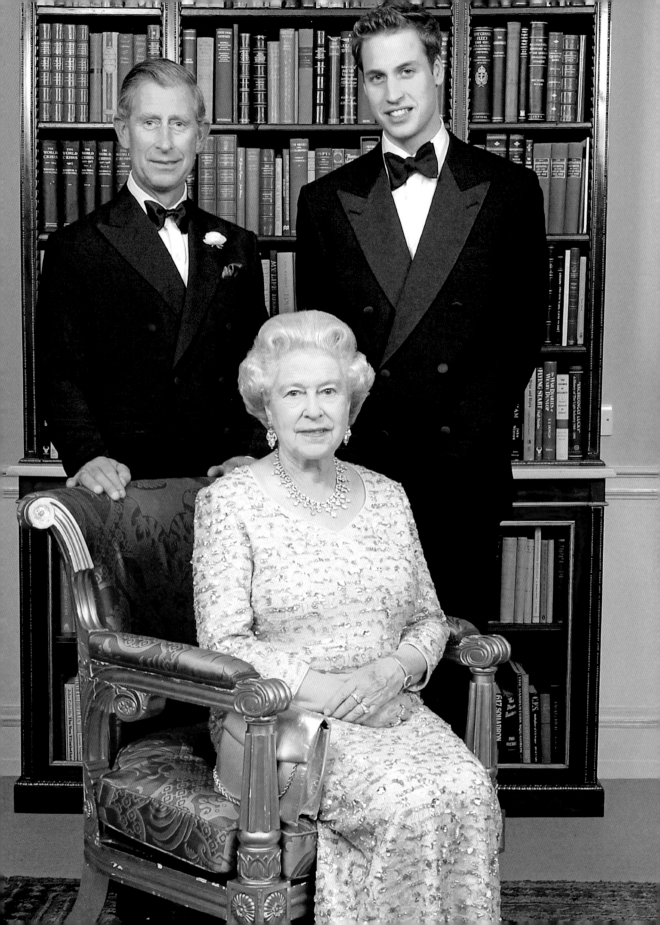

The Prince and Princess of Wales were determined to make the childhoods of William and his younger brother Prince Harry – born two years later – as normal as possible. At the age of three, William went to nursery school where he learned to socialise with other children. Two years later he went to Wetherby School in Notting Hill, then boarded at Ludgrove School in Berkshire before starting at Eton College in September 1995.

Despite Charles and Diana's eventual separation, their sons knew how much both parents loved them, and the boys in turn adored their parents. When their mother died in 1997 they were, quite naturally, devastated. In public William and Harry, just 15 and 12 respectively, kept their emotions under control with a maturity beyond their tender years.

Secure in his home life with his father and brother, and with his grandmother, The Queen, providing what William later called 'a strong female influence' who did not hesitate to discipline him when necessary, William continued to do well at school. After A levels he took a gap year before going up to St Andrews University in Scotland where he would meet the girl who would one day become his wife.

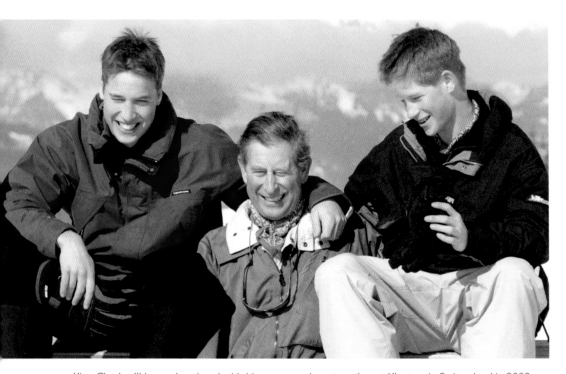

King Charles III has a close bond with his sons, seen here together at Klosters in Switzerland in 2000.

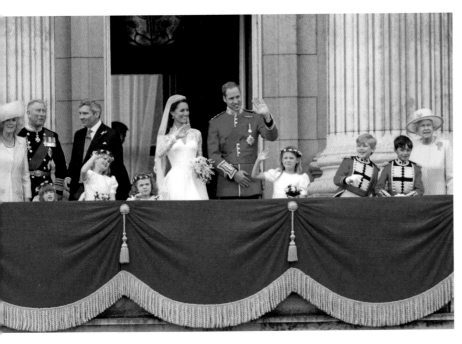

William and Catherine on the balcony at Buckingham Palace following their wedding at Westminster Abbey, 29 April 2011.

Catherine Middleton, born into an ordinary, loving middle-class family in January 1982, was the best of friends with Prince William for over a year before their relationship blossomed into romance. Catherine was popular with the rest of the Royal Family and coped admirably with the often over-zealous attention of the press.

Although, like his father before him, Prince William could have had his pick of European princesses and aristocratic young women, in November 2010 he and Catherine – clearly very much in love – were engaged. William presented his bride-to-be with an engagement ring that held special memories: the beautiful sapphire surrounded by 14 brilliant-cut diamonds and set in a white-gold band was the one that Prince Charles had given to William's mother, Princess Diana, on their engagement.

When William and Catherine married at Westminster Abbey on 29 April 2011, thousands of people throughout Britain celebrated and millions more around the world watched this happiest of royal occasions on television.

A NEW PRINCE AND PRINCESS OF WALES

The death of his grandmother, Queen Elizabeth II, saw Prince William elevated to first in line to the throne. He and his wife, who were given the titles Duke and Duchess of Cambridge on their wedding day, are now the Prince and Princess of Wales.

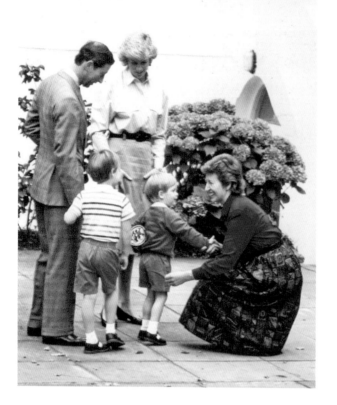

LEFT: Prince Harry and big brother Prince William arrive with their parents for Harry's first day at Mrs Mynor's nursery school in Notting Hill in September 1987.

OPPOSITE: Prince Harry, just returned from Afghanistan, leaving the terminal at RAF Brize Norton in Oxfordshire with his father and brother. It was 1 March 2008 – St David's Day – and Charles, as Prince of Wales, wore a leek, the national symbol of Wales, on his lapel.

Prince Harry

Charles and Diana could not have been more thrilled at the birth of a second son, Henry Charles Albert David (always known as Harry) on 15 September 1984. They now had what Diana herself termed 'an heir and a spare', although at that time, had their first child been a girl, the Succession to the Crown Act would have dictated Harry as heir to the throne after Charles.

Prince Charles was fascinated by his sons' different characters. In his early years Harry was a more placid child than his boisterous big brother, but the two were soon playmates and good friends. From an early age their father shared his love of the countryside with the boys and taught them to hunt, shoot and fish.

Schooldays saw Harry following in William's footsteps to Wetherby, Ludgrove and Eton. Their father was conscientious about turning up for parents' meetings and was an easy conversationalist with other children and their parents. Both William and Harry were popular with their peers and excelled at sport, including polo – another activity which, along with skiing, they were able to enjoy with their father.

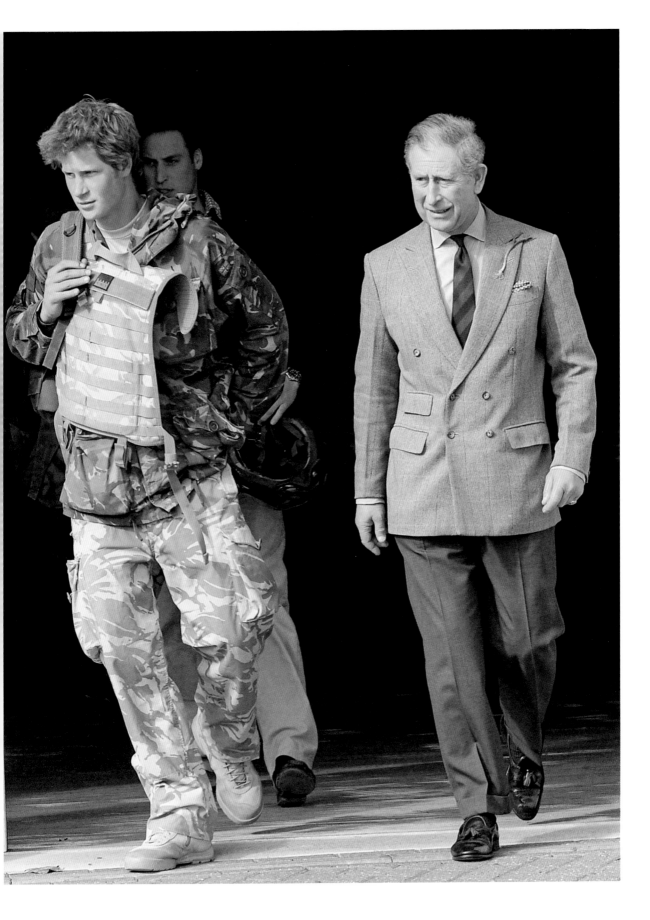

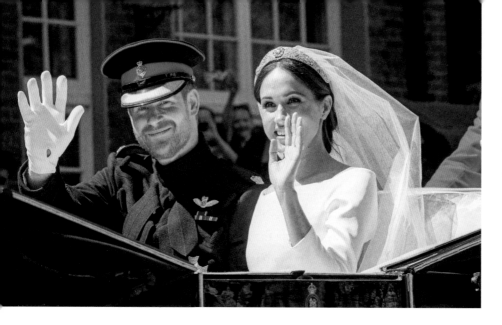

Their wedding ceremony over, Harry and Meghan delighted the crowds when they toured the streets of Windsor in a horse-drawn Ascot Landau.

After completing his A levels, Harry took a gap year, working in a cattle station in Australia and with orphaned children in Lesotho. He then joined the Royal Military Academy at Sandhurst in May 2005, passing out in April 2006. This time William followed in his younger brother's footsteps, joining RMA Sandhurst in January 2006 and passing out in December that year before training in the Royal Navy and RAF. After receiving his wings in 2008, William served as a helicopter pilot, first with RAF Search and Rescue and then with the East Anglian Air Ambulance.

Harry, meanwhile, spent ten years in the armed forces. He trained as an Apache helicopter pilot and was twice deployed on tours of duty to Afghanistan; as a co-pilot gunner, he participated in at least one Hellfire missile attack on the Taliban. Prince Charles was proud of his son's bravery but confessed to anxiety in not knowing Harry's whereabouts.

Prince Harry ended his operational duties in 2015 and Prince William finished his employment as a helicopter pilot in summer 2017. Both became working

A STIFF UPPER LIP

Mental health is a subject close to both William and Harry's hearts. In 2017, the brothers spoke of how they had suffered by following the protocol expected of them as members of the Royal Family and keeping a 'stiff upper lip' following their mother's death in 1997. They have said that walking behind Diana's coffin on the day of her funeral was one of the hardest things they had ever had to do.

royals, supporting their grandmother and father in royal duties. Before leaving the forces, Harry vowed to work to support service personnel who have been injured, physically and/or mentally. One of his initiatives has been the Invictus Games, an international sporting event for wounded, injured and sick servicemen and women, both serving and veterans. The first games were held in London in 2014.

After months of media speculation, it was at the 2017 Invictus Games, held that year in Toronto, Canada, that Harry and American actress Meghan Markle were photographed together officially as a couple for the first time. Meghan had been best known for her role in the television drama *Suits*, and there was an air of Hollywood glamour when the couple married at St George's Chapel, Windsor on 19 May 2018. The public loved the royal pair, created Duke and Duchess of Sussex on their wedding day. Their first child, Archie, was born a year later.

However, in 2020 came the announcement that they were going to live in the United States, seeking financial independence and the privacy that they felt they were unable to enjoy in the United Kingdom. As non-working royals, Harry and Meghan are no longer permitted to use the titles His and Her Royal Highnesses.

Their decision put a strain on Harry's close relationship with his elder brother. Nevertheless, the Duke and Duchess of Sussex remain much loved members of the Royal Family. Speaking on 9 September 2022, in his first address to the nation following the death of The Queen, King Charles III spoke of his 'love for Harry and Meghan as they continue to build their lives overseas'.

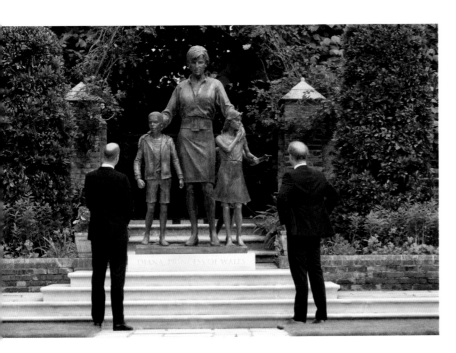

On 1 July 2021, which would have been the 60th birthday of Diana, Princess of Wales, William and Harry were reunited to unveil a statue of their mother in the Sunken Garden at Kensington Palace.

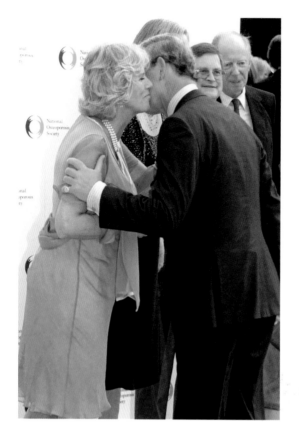

LEFT: Their first public embrace: Prince Charles is greeted by Camilla Parker Bowles as he arrives at Somerset House, London for the 15th anniversary reception for the National Osteoporosis Society in 2001.

OPPOSITE: Charles and Camilla, as Duke and Duchess of Cornwall, leave St George's Chapel, Windsor following the service of prayer and dedication for their wedding, 9 April 2005. The titles Duke and Duchess of Cornwall have now passed to William and Catherine.

Camilla, Queen Consort

Camilla Rosemary Shand was born in London on 17 July 1947, delivered by the same obstetrician who would deliver Prince Charles the following year. Hers was a happy childhood growing up in East Sussex where she and her siblings enjoyed the countryside, with days spent picnicking, camping, walking dogs and horse riding. Pony-mad Camilla rode with the hunt from the age of nine, and it was eventually to become a hobby that she and Prince Charles enjoyed together.

Camilla first met the man who was to become her first husband, Andrew Parker Bowles, in 1966. They had two children together, Tom and Laura, but it was not the happiest of marriages. After their divorce in 1995, Camilla set up a new family home for her and her children: Ray Mill House in Wiltshire.

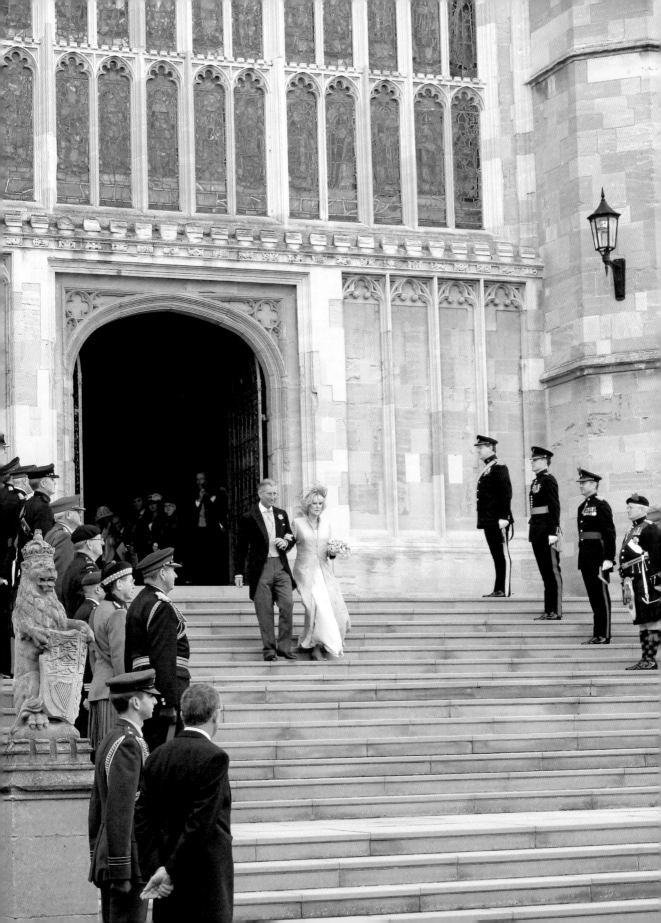

Ever since they first met in 1972, Camilla was someone Charles could turn to, knowing that anything he discussed with her would be treated with complete confidentiality. She was to become the person who helped him through dark moments of self-doubt and despair.

After Diana's death, Charles and Camilla started to bring their burgeoning relationship out of the shadows, and in December 1997 Charles, William and Harry took part in a hunt at which Mrs Parker Bowles was also present. Charles and Camilla were first photographed together as a couple in January 1999 as they left the Ritz Hotel in Piccadilly following a party for Camilla's sister, Annabel.

It has been said that The Queen did not initially approve of the relationship, but her son was not going to negotiate: he was determined to spend the rest of his life with the woman he loves. In 2000, his mother relented and met Camilla, briefly, at a 60th birthday party hosted by Charles that June for his cousin, the ex-King Constantine of Greece, grandson of Prince Philip's uncle.

On 10 February 2005, Clarence House announced that the Prince of Wales and Camilla Parker Bowles were engaged. Charles' formal request to The Queen before proposing was a requirement of the Royal Marriages Act of 1772. Charles presented his bride-to-be with a platinum and diamond ring that had once belonged to the Queen Mother. Princes William and Harry were told of the engagement some weeks previously; when the news became public they issued a joint statement, expressing their happiness for their father and Camilla and wishing them 'all the luck in the future'.

The question of the Prince of Wales marrying Camilla Parker Bowles raised constitutional issues for both the Church of England and the monarchy. Although church rules on the remarriage of divorcees are complicated, as early as 1998 the Bishop of Durham had said there was no reason why Charles could not remarry and still maintain the moral authority to become Head of the Church. The couple married on 9 April 2005. There were two ceremonies, both joyous affairs. The civil ceremony took place in Windsor Guildhall. Although The Queen and Prince Philip were not at that ceremony, they did attend the service of prayer and dedication that followed, led by the Archbishop of Canterbury in St George's Chapel. At a reception later that day, The Queen spoke of her pride in the couple, happy in the knowledge that her son was 'home and dry with the woman he loves'.

Camilla, Duchess of Cornwall with her husband and mother-in-law, Her Majesty The Queen, arriving at Royal Ascot in June 2013, an event that is always a favourite on the royal calendar.

On her marriage, Camilla became Duchess of Cornwall – only the third woman in history to bear that title. The others were the wife of King George II, Caroline of Ansbach, and King George V's wife, Mary of Teck – King Charles III's great-grandmother.

The hard-working Camilla has proved to be the perfect wife for Charles, always supporting him with quiet dignity and grace. Perhaps the most significant recognition of her loyal support of the Royal Family came in February 2022, when Queen Elizabeth II, in a message marking the 70th anniversary of her accession, spoke of her 'sincere wish' that Camilla would have the title Queen Consort 'when, in the fullness of time, my son Charles becomes King'. A little over six months later, that wish was to come true.

SUPPORTING CHARITIES

Like other members of the Royal Family, the Queen Consort is hugely involved as patron or president of dozens of charities. Even before her marriage to Prince Charles she was involved with the Royal Osteoporosis Society (then the National Osteoporosis Society). It is a charity close to her heart as her mother, Rosalind Shand, and grandmother, Sonia Keppell, both died of the disease. The Queen Consort has supported the charity since 1994, became a patron in 1997 and president in 2001.

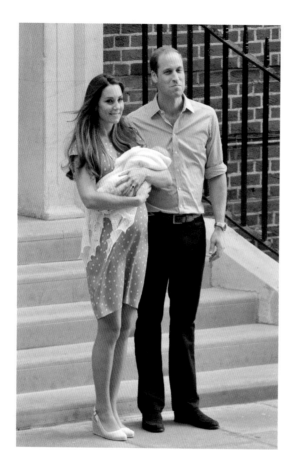

A Proud Grandfather

The birth of William and Catherine's first child, George Alexander Louis, on 22 July 2013 meant that for the first time since the reign of Queen Victoria, when her great-grandson – the future King Edward VIII – was born in 1894, the monarchy had three generations of heirs to the throne.

Prince Charles was thrilled at the latest addition to the Royal Family, saying, 'Both my wife and I are overjoyed at the arrival of my first grandchild.' He added, 'Grandparenthood is a unique moment in anyone's life, as countless kind people have told me in recent months, so I am enormously proud and happy to be a grandfather for the first time.'

Six months prior to Prince George's birth, The Queen overturned a 1917 decree that meant if the first child of William and Catherine (then the Duke and Duchess of Cambridge) had been a daughter, she would have been known as Lady, rather than Her Royal Highness. A Letters Patent issued by King George V had limited titles within the Royal Family, meaning that only a firstborn son would automatically become a Prince, and excluded all future sons and daughters from a similar title. However, the new declaration stated that 'all the children of the eldest son of the Prince of Wales should have and enjoy the style, title and attribute of royal highness with the titular dignity of Prince or Princess prefixed to their Christian name or with such other titles of honour'.

While Charles and Camilla were in Canada on a four-day visit in May 2014, he delivered an impassioned plea to the Canadian people to be 'mindful of the wellbeing of all our grandchildren'. He has long been an environmental advocate, and spoke of the 'huge challenges' facing the world, including youth unemployment, the growing gap between rich and poor, the need to increase opportunities for women and girls, climate change, the dangers of over-fishing and deforestation, and the battle to advance human rights and democracy. He admitted that since becoming a grandfather, these issues had come into even sharper focus.

A few days before the birth of William and Catherine's second child in 2015, Prince Charles revealed that he was hoping for a granddaughter. That hope was to become a reality when on 2 May Charlotte Elizabeth Diana was born. The 'absolutely delighted' Charles and Camilla met Princess Charlotte for the first time at Kensington Palace the day after her birth, as did Catherine's parents, Michael and Carole Middleton.

Had Charlotte been William and Catherine's firstborn, history would have been made as a change to the Succession to the Crown Act in 2013 would have seen her

AN EXTENDED FAMILY

Charles is step-grandfather to his wife's five grandchildren. The Queen Consort's son, Tom Parker Bowles, has two children: Lola, born in 2007, and Freddy, born in 2010. Her Majesty's daughter, Laura Lopes, is mother to a daughter, Eliza, born in January 2008, and twin boys, Gus and Louis, born in December 2009.

Newborn Archie in the arms of his mother, the Duchess of Sussex. Looking on are the baby's father, the Duke of Sussex, his paternal great-grandparents, Queen Elizabeth II and the Duke of Edinburgh, and his maternal grandmother, Doria Ragland.

become monarch ahead of any future brothers. However, even though William and Catherine's third child is a boy, Princess Charlotte will always be next in line to the throne after Prince George, until he has children. Prince Louis Arthur Charles, George and Charlotte's younger brother, was born on 23 April 2018.

Since Prince Louis was born, the King has become a grandfather twice more, this time to the children of the Duke and Duchess of Sussex. Archie Harrison Mountbatten-Windsor was born in London on 6 May 2019 and his sister in Santa Barbara, California on 4 June 2021. She is named Lilibet Diana Mountbatten-Windsor: Lilibet the childhood family name of her great-grandmother, Queen Elizabeth II, and Diana that of her paternal grandmother.

LEFT: Watched by hosts Ant and Dec, the then Prince of Wales made a speech during The Prince's Trust Celebrate Success Awards at the London Palladium in March 2017.

OPPOSITE: Prince Charles was hands-on when he visited the House of Dorchester chocolate factory in Poundbury, Dorset in 2008. This mixed-use urban extension of the town of Dorchester is built on land owned by the Duchy of Cornwall, and based on principles advocated by the monarch.

Patronages and Passions

King Charles III has long been known as a man who speaks his mind. Unlike his mother's public neutrality on social and political issues, when, as Prince of Wales, he felt strongly about an issue he made his opinion heard and proved a formidable force in bringing the right people together to make a difference to his causes.

As a student at Cambridge, the Prince of Wales was urging architects to take into account the views of ordinary people when designing homes and public buildings. Speaking at the 150th anniversary of the Royal Institute of British Architects at Hampton Court Palace in 1984, he referred to the planned extension to the 19th-century National Gallery on Trafalgar Square in London as a 'monstrous carbuncle on the face of a much-loved and elegant friend'. His speech had dramatic impact and the original plans were rejected.

On his father's accession Prince William inherited the Duchy of Cornwall, in line with the original charter that passes the Duchy to the eldest son of the monarch and heir to the throne. It was on land owned by the Duchy that Poundbury in Dorset was started in 1993. This 'urban village' has been built on the principles of architecture and urban planning long championed by King Charles: architecture reflecting local character; integrated affordable housing; a walkable community; the integration of homes with retail outlets, offices and factories, and public areas. In 2019, *The Times* newspaper reported that Poundbury had become 'wildly successful'.

King Charles has followed his father's lead as a conservationist and from the 1970s has been forceful in raising his concerns about the environment. At a conference at the Royal Agricultural College in Cirencester in 1983, he criticised the wanton depletion of fossil fuels and attacked modern farming methods that use herbicides and pesticides. Two years later he vowed publicly that he and his family would not eat genetically modified foods.

On a visit to the USA in November 2005, the then Duke and Duchess of Cornwall spent time in the ecological friendly San Francisco, where Charles delivered a speech blaming droughts, heatwaves and flooding on climate change, and predicted worse to come. He implored the business community to take action and at the end of the impassioned speech a member of the audience shouted out, 'Come and be our President!' It brought the house down.

However, by Charles' own admission the roles of King and Prince of Wales are very different. In an interview in 2018 he said that as monarch he would have to act within 'constitutional parameters' that would not allow him to be as opinionated and vocal as in the past. He emphasised the point in his first public address as King, saying that he would no longer be able to give as much time and energy to the charities and issues for which he cares so deeply, but added: 'I know this important work will go on in the trusted hands of others.'

Over the years, His Majesty has established more than 20 charities. His wide range of interests has been reflected in The Prince of Wales's Charitable Fund (PWCF), founded as The Prince's Charities in 1979 as a group of not-for-profit organisations of which he has been patron or president. The PWCF has raised millions of pounds annually in support of initiatives at home and abroad in support of healthcare, education, the arts, global environmental sustainability, the built environment and rural affairs.

Perhaps the best known of Charles' charities has been The Prince's Trust, the seed of the idea for which was formed in 1971 when the Queen Mother wrote to her eldest grandson, who was at that time in the Royal Navy, of her concern about the high level of unemployment among boys leaving school. By 1974, the Prince of Wales was speaking publicly about his wish to assist teenagers and young adults seeking the challenge of creating small business enterprises. He set up a trust to make small grants for self-help schemes; it was the beginning of an initiative that evolved to become The Prince's Trust. It was launched in June 1976, with part of the initial

In September 2021, Charles and Camilla – who at that time used their titles the Duke and Duchess of Rothesay when in Scotland – unveiled a knitted art installation during a visit to Dumfries House.

funding coming from his severance pay on leaving the armed services. Over 45 years later, the good work continues, with disadvantaged young people aged 13 to 30 who are unemployed or struggling at school being helped to get into work, education or training. Some have gone on to become household names, among them actors Idris Elba and David Oyelowo, and musicians Naughty Boy and the Stereophonics.

In 2018 The Prince's Foundation was created when several other trusts merged; it is based in Dumfries House in Ayrshire, Scotland. The sustainable approach that the organisation champions sees training provided for people of all ages and backgrounds in traditional arts and heritage craft skills, architecture and design, science, engineering, horticulture, wellbeing and hospitality. The results enable the care and regeneration of places, both nationally and internationally, where communities thrive and are enjoyed by visitors.

A PERSONAL TOUCH

It is not only with charities that King Charles III has demonstrated a long history of his kind and thoughtful nature. He also makes very private and personal gestures to those in need, whether friends or strangers – for example, writing letters of support to cancer patients he has met at receptions, and instructing his staff to keep him informed of their progress.

Homes Fit for a King

King Charles III's early years were spent with his parents at Clarence House, the mansion built in 1825 by John Nash for the Duke of Clarence. When Charles was Prince of Wales, it became his official London residence after the death of the Queen Mother in 2002. He and his sons moved into the classically proportioned building next to York House – their previous London home in St James's Palace – on 4 August 2003, the anniversary of the Queen Mother's birth.

On Queen Elizabeth II's accession in 1952, she and Prince Philip moved into Buckingham Palace with their two small children, Prince Charles and Princess Anne. When he turned 21, as a mark of his adulthood the Prince of Wales was permitted his own suite of rooms, which overlooked The Mall and St James's Park.

The original Buckingham House, built in the early 1600s, was enlarged by John Nash during the reign of King George IV to become the imposing Buckingham Palace. Prince Charles' great-great-great-grandmother Queen Victoria chose it as the official home of the sovereign when she ascended the throne in 1837; it has remained so ever since, and is once more Charles' London home now that he is monarch.

Buckingham Palace belongs to the Crown, as do Windsor Castle, Holyrood Palace and Hillsborough Castle. By virtue of his accession, these properties passed to King Charles on The Queen's death.

Windsor Castle is the monarch's official country residence. It was The Queen's weekend retreat and from 2020 became her more permanent home instead of Buckingham Palace. Dating from the time of William the Conqueror, Windsor

Castle has a 900-year association with the Royal Family. In fact the surname Windsor was adopted by George V in 1917 in reference to this heritage, thereby creating the House of Windsor. Today the castle is both a working building and a royal home, to which visiting Heads of State are welcomed and where official ceremonies, such as the investiture of Knights of the Garter, are held in St George's Chapel in the castle's grounds.

The Palace of Holyrood House in Edinburgh is the Scottish equivalent to Buckingham Palace and the monarch's official residence in Scotland. It was formally designated a royal residence in the 1920s, since which time it has been the grand setting for investitures, audiences and royal garden parties.

Historic Royal Palaces took over the management of Hillsborough Castle and Gardens in 2014. Then began a five-year renovation of the official Northern Ireland residence of the monarch, which the Royal Family use as their base when visiting the country.

During their marriage, Kensington Palace (another residence belonging to the Crown) was Charles and Diana's London home and where they raised their sons. Their country home was Highgrove, near Tetbury in Gloucestershire, although Diana always preferred city life. Charles and Camilla, however, have a shared love of country living and have been able to enjoy together all the pleasures that Highgrove provides.

The Duchy of Cornwall purchased the Highgrove Estate for the Prince of Wales in June 1980. Although more modest than other royal residences, Charles was immediately attracted to the quality of light that flooded the hall and the promise

HONEYMOON DESTINATION

Birkhall, an 18th-century stone house on the Balmoral Estate, is a much loved residence for Charles and Camilla, and was the former home of the Queen Mother who described it as a 'little big house'. It was at the tranquil Birkhall that Charles and Camilla chose to honeymoon, embracing the clashing tartan wallpaper, threadbare carpets and cluttered rooms that preserve the essence of what the Queen Mother loved. One thing that they did change was the myriad grandfather clocks in the dining room, which now chime in unison; they never did in Charles' grandmother's day, much to her amusement.

The gardens at Highgrove have been a passion of King Charles III since the estate was purchased for him by the Duchy of Cornwall in 1980.

of what the neglected gardens, over which towered a 200-year-old cedar, could be. Since then, Charles and a dedicated team – among them, at different times, Mollie Salisbury (wife of the 6th Marquess of Salisbury), Miriam Rothschild, Rosemary Verey and Sir Roy Strong – have devoted much time and energy to transforming the gardens, now renowned as some of the most inspiring and innovative in the United Kingdom. The King manages his gardens using strict sustainable principles that work in harmony with nature.

Although Charles had been Prince of Wales for many years, it was not until 2007 that he acquired his Welsh home, Llwynywermod, near Llandovery in Carmarthenshire. Purchased by the Duchy of Cornwall, Charles was captivated by the rolling landscape surrounding a cluster of farm buildings. The farmhouse, refurbished using local materials and a showcase for Welsh crafts, has been a private residence of Charles and Camilla, and where they have stayed on their annual tour of Wales and during other visits.

Like his mother and grandmother before him, the privately owned Balmoral Estate in Royal Deeside has always held a special allure for King Charles, into whose ownership it came when he ascended the throne. It has long been customary for the Royal Family to spend their summer break at Balmoral and it was here that Her Majesty Queen Elizabeth II died in September 2022.

Sandringham House in Norfolk is another privately owned royal home inherited by King Charles from his mother. The Sandringham Estate was purchased in 1862 by the future King Edward VII and the manor house has been a favourite royal residence ever since. He started the tradition of spending family Christmases here and it was from Sandringham in 1932 that George V broadcast the first royal Christmas message.

Royal Duties

On 9 September 2015, Queen Elizabeth II reached a remarkable milestone in Britain's royal history when she became our longest-reigning monarch, exceeding the record of 63 years and seven months set by Queen Victoria. When Queen Elizabeth died on 8 September 2022, she had reigned for a remarkable 70 years, seven months and two days.

Despite her advancing years, The Queen always showed remarkable stamina, but in 2014 Buckingham Palace announced that while Her Majesty would continue to serve as patron to the hundreds of charities and institutions with which she was involved, she would now share the workload with her family. From then on, all four of The Queen's children took on a more significant role in her demanding schedule, as did her grandsons Princes William and Harry, although prior to Her Majesty's death, circumstances dictated that Prince Andrew and Prince Harry no longer carry out royal public duties. The Queen's decision to take a step back followed the example set by the Duke of Edinburgh who relinquished some of his patronages when he turned 90 in 2011; in 2017, aged 96, he retired fully from public engagements.

King Charles III was instilled with the expectations of constitutional traditions from an early age. A major part of his role as heir to the throne was to support the sovereign. Stepping up to carry out more of The Queen's royal duties was something Charles welcomed with his customary diligence, demonstrating the unquenchable curiosity and pleasure he takes in meeting people.

As Prince of Wales, Charles regularly carried out investitures on his mother's behalf, and represented her by welcoming dignitaries to the United Kingdom and attending State dinners during State visits. Each year, he and the Duchess of Cornwall travelled overseas at the specific request of the Foreign and Commonwealth Office, developing British diplomatic interests and promoting the United Kingdom's profile abroad. He also represented The Queen at a variety of other overseas events, including State funerals. In fact, his marriage to Camilla in 2005 was delayed by 24 hours from the originally planned date because he was attending the funeral of Pope John Paul II in his royal capacity.

Now, as King of the United Kingdom and 14 other Commonwealth realms, the duties of a sovereign all fall to Charles. Among these are the weekly audience with the Prime Minister and regular meetings with the Privy Council. Attending to the contents of the iconic red dispatch boxes is a daily task, dealing with a multitude of communications, official papers and documents from various government departments.

Charles has already attended the annual State Opening of Parliament (which marks the formal start of the parliamentary year) many times. In May 2022, history was made when, by special order of The Queen, he delivered the Monarch's Speech. Prior to that, throughout her 70-year reign Her Majesty had only missed the event twice: in 1959 and 1963 when she was expecting her two youngest children.

In another break with tradition, at the 2022 Trooping the Colour – the Sovereign's Birthday Parade – Prince Charles inspected the guards and took the salute on behalf of his mother. She had missed the event only once before during her reign: that was in 1955 when it was cancelled during the general strike. Nevertheless, at Trooping the Colour in 2022 The Queen still made her time-honoured appearance on the balcony at Buckingham Palace for the RAF fly-past.

King Charles III is also Head of the Commonwealth, the role previously held by his grandfather King George VI and mother Queen Elizabeth II. Although it is

On 27 September 2022, the cypher of King Charles III was revealed. It shows the monogram CRIII (the R for Rex being Latin for King), along with a stylised Tudor Crown. The Scottish version shows a representation of the Crown of Scotland.

not a hereditary role, following the 2018 Commonwealth Heads of Government Meeting, Commonwealth leaders declared that Charles would be the next Head of the Commonwealth. It was a decision that delighted The Queen, who all her life had made known her enduring commitment to the role, believing her responsibilities to the Commonwealth to be as important as her duties in the United Kingdom. Over the years, Charles made numerous visits on her behalf to Commonwealth countries, so is well versed in the duties associated with the role.

In his address to the nation on 9 September 2022, The King pledged to 'uphold the Constitutional principles at the heart of our nation'. Making his promise to the United Kingdom, the Realms and territories across the world he said, 'I shall endeavour to serve you with loyalty, respect and love, as I have throughout my life.'

And now His Majesty's eldest son is supporting him. Following the death of his grandmother The Queen, Prince William said he would honour her memory 'by supporting my father, The King, in every way I can'.

CHANGES TO THE FAMILIAR

A change of sovereign also marks a change in everyday objects that bear the monarch's portrait, such as stamps, coins and banknotes, and the royal cypher displayed on government buildings, State documents and, perhaps most familiar of all, postboxes. New coins, for example, follow the centuries-old tradition of the monarch facing in the opposite direction to his predecessor. Some changes will take time to evolve; in particular, existing postboxes will continue to bear the cypher of previous kings and queens until such time as they need replacing.

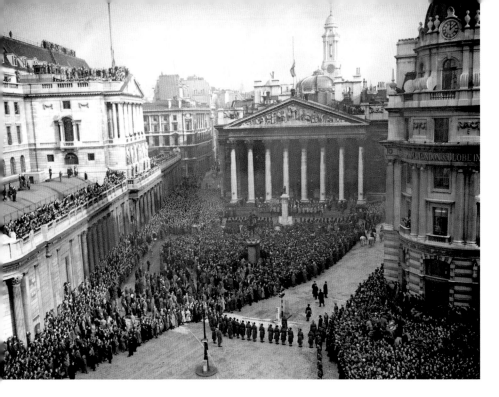

The Accession

When Her Majesty Queen Elizabeth II died at Balmoral on 8 September 2022, her son and heir immediately acceded the throne as the new sovereign.

King Charles III returned to London the next day in preparation for the formal proclamation at the Accession Council. This took place at 10am on 10 September at St James's Palace. Flags, flown at half mast since The Queen's death, were raised – briefly – to acknowledge the start of the new monarch's reign.

It was the first time in history that the royal proclamation was broadcast on television, giving the world the privilege of observing the ancient ceremony. It was also the first time that a woman presided over such an event, the honour falling to Lord President of the Council and Leader of the House of Commons Penny Mordaunt, who had been appointed only four days earlier.

The ceremony began in the throne room at St James's Palace with a meeting held by the Privy Council, the formal body of advisors to the monarch, in the presence of the Queen Consort and the Prince of Wales. Others in attendance –

all members of the Privy Council – included Prime Minister Liz Truss and former Prime Ministers John Major, Tony Blair, Gordon Brown, David Cameron, Theresa May and Boris Johnson. It was then that the Privy Council officially proclaimed the former Charles, Prince of Wales as monarch of the United Kingdom of Great Britain and Northern Ireland, and head of the Commonwealth, and introduced his regnal name: Charles III.

Our new King was present at the next part of the meeting where he delivered a personal address relating to the death of The Queen, closing with the words: 'My mother's reign was unequalled in its duration, its dedication and its devotion. Even as we grieve, we give thanks for this most faithful life.'

At this, the first meeting His Majesty held with his Privy Council, he signed an oath upholding the independence of the Church of Scotland. As His Majesty prepared to sign the large documents, he motioned in frustration for an aide to remove the box of pens taking up space on the desk. It was a very human moment and a suggestion of the stress King Charles must have been under … and of the

ACCESSION PROCLAMATION

Whereas it has pleased Almighty God to call to His Mercy our late Sovereign Lady Queen Elizabeth the Second of Blessed and Glorious Memory, by whose Decease the Crown of the United Kingdom of Great Britain and Northern Ireland is solely and rightfully come to The Prince Charles Philip Arthur George: We, therefore, the Lords Spiritual and Temporal of this Realm and Members of the House of Commons, together with other members of Her late Majesty's Privy Council and representatives of the Realms and Territories, Aldermen and Citizens of London, and others, do now hereby with one voice and Consent of Tongue and Heart publish and proclaim that The Prince Charles Philip Arthur George is now, by the Death of our late Sovereign of Happy Memory, become our only lawful and rightful Liege Lord Charles the Third, by the Grace of God of the United Kingdom of Great Britain and Northern Ireland and of His other Realms and Territories, King, Head of the Commonwealth, Defender of the Faith, to whom we do acknowledge all Faith and Obedience with humble Affection; beseeching God by whom Kings and Queens do reign to bless His Majesty with long and happy Years to reign over us. Given at St. James's Palace this tenth day of September in the year of Our Lord twenty thousand and twenty-two. GOD SAVE THE KING.

Welsh First Minister Mark Drakeford, speaking at the proclamation ceremony at Cardiff Castle in Wales.

short fuse he inherited from his father, the Duke of Edinburgh. It has been said that Prince William also shares this family trait.

At 11am, trumpeters heralded the Principal Proclamation, made from the balcony of St James's Palace, and a royal salute of 41 guns by the King's Troop Royal Horse Artillery boomed from Hyde Park. Among those watching the proceedings were several members of the extended Royal Family: Prince Michael of Kent; Prince Richard, Duke of Gloucester and his wife Birgitte, Duchess of Gloucester; Prince Edward, Duke of Kent and his wife Katherine, Duchess of Kent; Lady Helen Taylor (daughter of the Duke and Duchess of Kent) and one of her sons, Cassius Taylor.

King Charles meeting with members of the cabinet at Buckingham Palace on 10 September 2022. Standing next to His Majesty is Liz Truss, who was in office as Prime Minister for only 44 days before resigning on 20 October. On 25 October King Charles formally invited her successor, Rishi Sunak, to form a government.

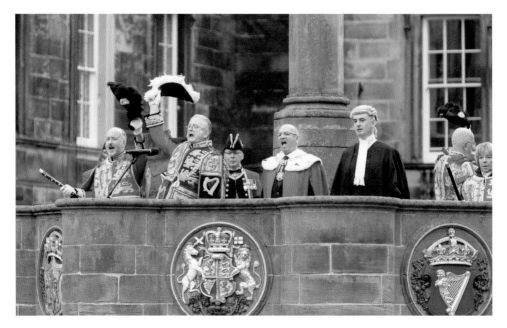

The proclamation at Mercat Cross on the Royal Mile, Edinburgh.

The Principal Proclamation was read by the Garter King of Arms, who officially proclaimed The King as Sovereign of the United Kingdom of Great Britain and Northern Ireland, including Supreme Head of the Church of England and Commander-in-Chief of Britain's Armed Forces, as well as Head of State of the Commonwealth and British territories around the world. The proclamation ended, shouts of 'God save The King' rang out and the National Anthem was performed by the Band of the Coldstream Guards.

As it tradition, the proclamation at St James's Palace was followed by the City Proclamation taking place on the steps of the Royal Exchange in the City of London at 12 noon. Another royal salute of 62 guns was fired, this time by the Honourable Artillery Company at the Tower of London. Later that afternoon. King Charles III hosted an audience with the Prime Minister and the cabinet.

The proclamation in Wales was also held on 10 September, at Cardiff Castle. On Sunday 11 September the proclamation was made at Mercat Cross in Edinburgh and Hillsborough Castle in Royal Hillsborough, Northern Ireland, as well as in cities throughout the United Kingdom and across the Commonwealth.

It was the first step in the process of Charles becoming King, at the beginning of what was to be a busy and emotionally exhausting period for him and the rest

of the Royal Family in the lead-up to the State Funeral for Queen Elizabeth II. It was announced that this would take place on Monday 19 September.

On the Monday after the proclamations, the new King and his Queen Consort began a tour of the nations of the United Kingdom. At Holyrood in Scotland on 12 September, King Charles III made his first appearance as monarch at the Scottish Parliament. The following day, the royal couple flew to Northern Ireland. They received a warm welcome in Belfast, where they attended a service of reflection at St Anne's Cathedral. Later they headed to Royal Hillsborough, where crowds had lined the streets since the early hours of the morning to greet them.

On 16 September, Charles and Camilla were in Wales, the King addressing the Senedd in Cardiff. In a bilingual speech, King Charles III spoke of the special place Wales held in his mother's heart and of the privilege it had been for him to be Prince of Wales for so long. He went on to say that his son, the new Prince of Wales, has a 'deep love' for the nation.

It was then back to London, where Queen Elizabeth II had been lying in state in Westminster Hall since 14 September.

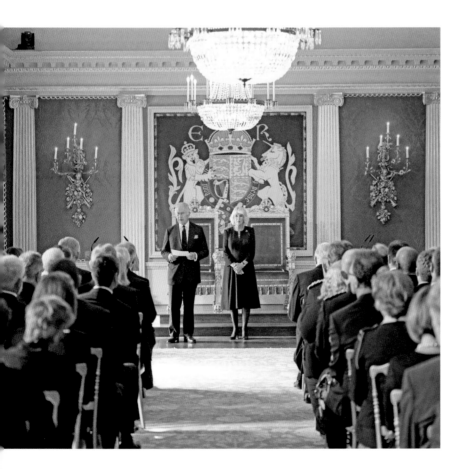

King Charles spoke to the main political parties in Northern Ireland at Hillsborough Castle, County Down on 13 September 2022, as part of his tour of the UK nations on which he was accompanied by the Queen Consort.

LEFT: The Queen's coffin lying in state in Westminster Hall.

OPPOSITE: King Charles III walks in the funeral procession of his mother, Queen Elizabeth II.

'My Dear Mother, the Late Queen'

On 18 September, the evening before Queen Elizabeth II's funeral, in a statement issued by Buckingham Palace King Charles spoke of how he and his wife had been 'moved beyond measure by everyone who took the trouble to come and pay their respects to the lifelong service of my dear mother, the late Queen'. He went on to thank the 'countless people who have been such a support and comfort' in his family's time of grief.

It was a time of grief lived out in the public eye, which began a whole week previously when on Sunday 11 September Queen Elizabeth II's English oak coffin left Balmoral and was driven to Edinburgh. On the six-hour journey, the hearse travelled through towns and villages in Aberdeenshire, Angus and Tayside where people turned out to pay their respects as Her Majesty passed by.

Having arrived in Edinburgh and been rested overnight at the Palace of Holyroodhouse, on 12 September the coffin was borne in procession to St Giles' Cathedral for a service of thanksgiving for the life of The Queen. The hearse was flanked by the Bearer Party from the Royal Regiment of Scotland, the over-riding sound the skirl of their bagpipes. Walking in procession were the King's Body Guard for Scotland, along with King Charles, the Princess Royal, Prince Andrew, Prince Edward and Vice-Admiral Tim Laurence. The coffin – draped in the Royal Standard of Scotland, on top of which were the Crown of Scotland and a wreath of white flowers, which included white heather from the Balmoral Estate – lay in state in the

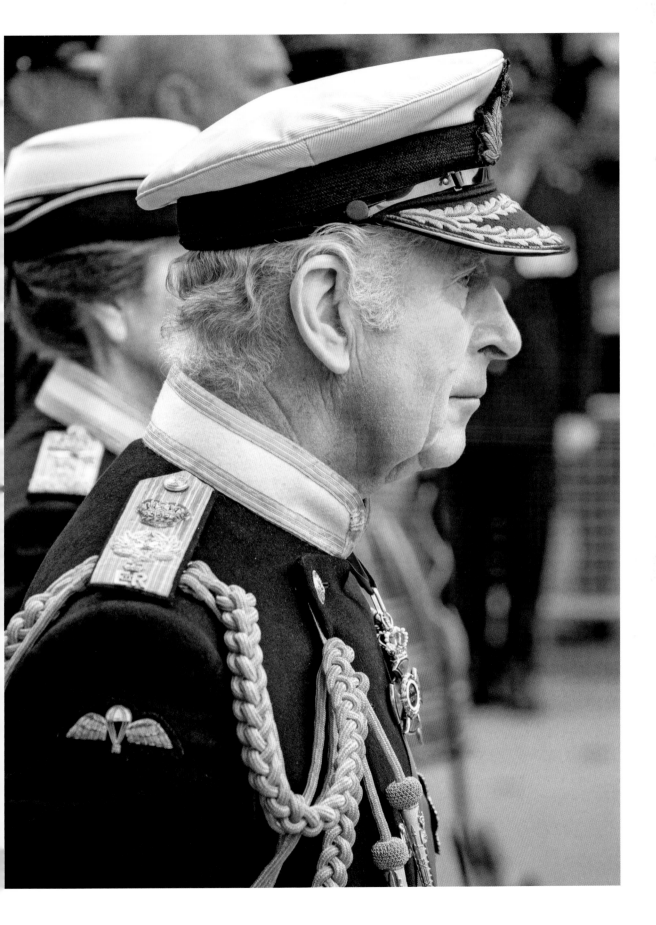

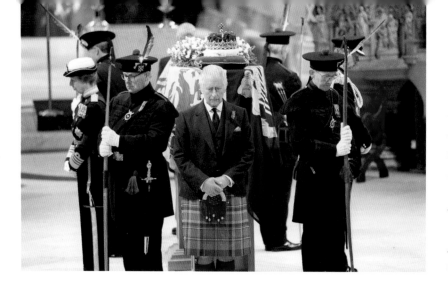

Dressed in his kilt of the Prince Charles Edward Stewart tartan, King Charles III stands vigil beside his mother's coffin in St Giles' Cathedral in Edinburgh. Also standing vigil were the Princess Royal (far left), Prince Andrew (beyond) and Prince Edward (far right).

cathedral for 24 hours. As thousands of members of the public filed past, one watch of the continuous silent vigil was kept by Her Majesty's four children.

On the Tuesday, the coffin was taken by road to Edinburgh Airport and flown to RAF Northolt, west London, before being driven to Buckingham Palace ahead of the lying in state at Westminster Hall.

On Wednesday 14 September, Big Ben tolled as The Queen left Buckingham Palace for the last time. Her coffin was taken in procession along The Mall on a gun carriage of the Kings Troop Royal Horse Artillery, arriving at Westminster Hall for the lying in state. Following on foot were The Queen's four children, joined by three of her grandsons: Prince William, Prince Harry and Peter Phillips. Over the course of five days, tens of thousands of people waited patiently – some for up to 24 hours – to bid their silent farewells to their Queen. What became known as 'The Queue' – up to 10 miles long – zigzagged from Southwark Park to Westminster.

Inside Westminster Hall, mourners filed past the catafalque on which the coffin lay, draped in the Royal Standard; on top were the Imperial State Crown resting on a purple cushion, a wreath of white flowers alongside it. There was a particularly poignant scene on Friday 16 September when King Charles, the Princess Royal, Prince Andrew and Prince Edward held vigil beside their mother's coffin. It was also an emotive moment the following day when all eight of The Queen's grandchildren – Prince William, Prince Harry, Peter Phillips, Zara Tindall, Princess Beatrice, Princess Eugenie, Lady Louise Mountbatten-Windsor and James, Viscount Severn – did the same.

There was much media comment and divided public opinion regarding the fact that both Prince Andrew and Prince Harry – no longer working royals and

ROYAL NAVY TRADITION

The privilege afforded to the Royal Navy of conveying the gun carriage bearing the monarch's coffin began after the horses pulling Queen Victoria's funeral carriage in 1901 reared up and threatened to bolt. Naval ratings immediately stepped in to replace the panicked horses and a new State Funeral tradition was born.

stripped of their military titles – were permitted to wear full uniform on their watches. For the funeral procession and service itself, they were not granted that privilege, wearing morning suits instead.

The lying in state drew to a close at 6.30am on the day of the funeral, Monday 19 September. Across the nation schools, shops, restaurants and other businesses closed as a mark of respect, giving many people of all ages the opportunity to watch the day unfold on television.

And what a day it was. The doors of Westminster Abbey opened at 8am, welcoming the 2,000 mourners invited to the funeral. Among them were Heads of State and royal families from across the world, along with British Prime Ministers past and present, leaders of Scotland, Wales and Northern Ireland, and members of the Royal Household.

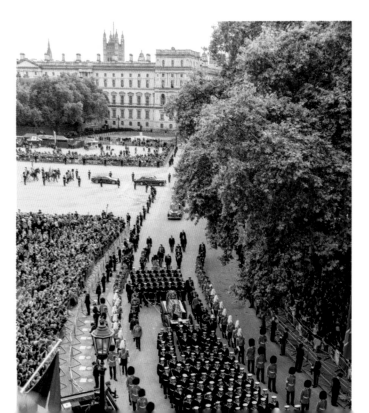

Heading from Horse Guards Parade, one of the landmarks taken in on the journey, Royal Navy ratings pull the State Gun Carriage bearing The Queen's coffin as the procession heads for Wellington Arch.

Her Majesty's coffin left Westminster Hall, borne on the State Gun Carriage drawn by 142 sailors of the Royal Navy. Walking solemnly behind were King Charles and other members of the Royal Family.

The Queen's coffin arrived at the Great West Door of Westminster Abbey and was placed in front of the high altar. Among the flowers on top of the coffin, chosen by King Charles and cut from the royal gardens of Buckingham Palace, Clarence House and Highgrove House, was a simple message, handwritten by him: 'In loving and devoted memory. Charles R'.

At 11am the service began, conducted by the Dean of Westminster, David Hoyle. The sermon was given by the Archbishop of Canterbury, Justin Welby, and the voices of the choir and congregation were raised in song. The service neared its conclusion with 'The Last Post', after which a two-minute silence was observed throughout the nation and across the world. Then came the National Anthem, followed by 'Sleep, Dearie, Sleep', a lament played by The Queen's Piper. The service was over.

The gun carriage, once more pulled by members of the Royal Navy, was taken in procession past London landmarks to arrive at Wellington Arch, applauded by the crowds all the way. At Wellington Arch, for the first time tears from a member of the Royal Family were seen when Princess Charlotte wept as her great-grandmother's coffin was transferred to the State Hearse. She and Prince George, the eldest children of the Prince and Princess of Wales and just seven and nine years old respectively, were the youngest royals to attend the funeral. Both displayed the brave solemnity and dignity so familiar within the Royal Family.

And so Her Majesty's coffin began its final journey, this time to Windsor. Arriving in the town, hundreds of people threw flowers in the wake of the hearse as it drove slowly up the Long Walk to the gates of Windsor Castle. The procession, which once more included senior personnel of the Royal Family, was accompanied by members of the armed services and the Royal Canadian Mounted Police. And who could fail to be moved when they saw one of The Queen's horses, Emma, a Highland Fell pony, watching the procession pass by, and two of Her Majesty's corgis, Muick and Sandy, waiting on the quadrangle at Windsor Castle as the cortège approached St George's Chapel?

At 4pm the committal service – led by the Dean of Windsor, David Conner, and with the sermon and blessing by the Archbishop of Canterbury – was broadcast live from St George's Chapel. Towards the end of the ceremony, the

The Queen's corgis, Muick and Sandy, at Windsor Castle, waiting for their beloved mistress to pass by one last time.

Imperial State Crown, orb and sceptre were moved from the top of the coffin to the high altar. Just before the coffin was lowered into the Royal Vault, King Charles placed on it a regimental flag: The Queen's Company Camp Colour of the Grenadier Guard. Then, as is tradition, the Lord Chamberlain broke his wand of office over the coffin, signifying the end of his service to The Queen as sovereign.

That evening, in a private family ceremony conducted by the Dean of Windsor, Her Majesty was buried in the King George VI Memorial Chapel, where her father and mother are buried, as are the ashes of The Queen's sister, Princess Margaret. Perhaps most significant of all, she was buried with her beloved husband, the Duke of Edinburgh, who died in April 2021. His coffin had been kept in the vault so that he could, eventually, be buried alongside his wife of 73 years.

The ten days of national mourning were over, though the Royal Family's period of mourning was observed for another seven days. During that time, flags continued to fly at half mast before being hoisted once more on 27 September.

It had been the most fitting and magnificent of State Funerals for a wonderful monarch, one of the grandest ceremonial events in history that will be forever remembered by those privileged to witness it.

Coronation Traditions and Pageantry

On 11 October 2022, Buckingham Palace announced the date for the Coronation of King Charles III: Saturday 6 May 2023. It was the exciting news that royalists everywhere had been waiting to hear.

Before he acceded the throne, Charles had made known that when he eventually became monarch he would be looking for a 'slimmed-down' monarchy with a core of royals rather than one that included extended family; what this will mean in reality will evolve over time. It had already been reported that King Charles would not want his Coronation to be the grand – and expensive – affair that his mother's had been in 1953. In fact the official announcement made it clear that the occasion would 'reflect the monarch's role today … while being rooted in long-standing traditions and pageantry'.

The traditions and pageantry that surround our monarchy are admired the world over and mean that King Charles III's Coronation, just like that of

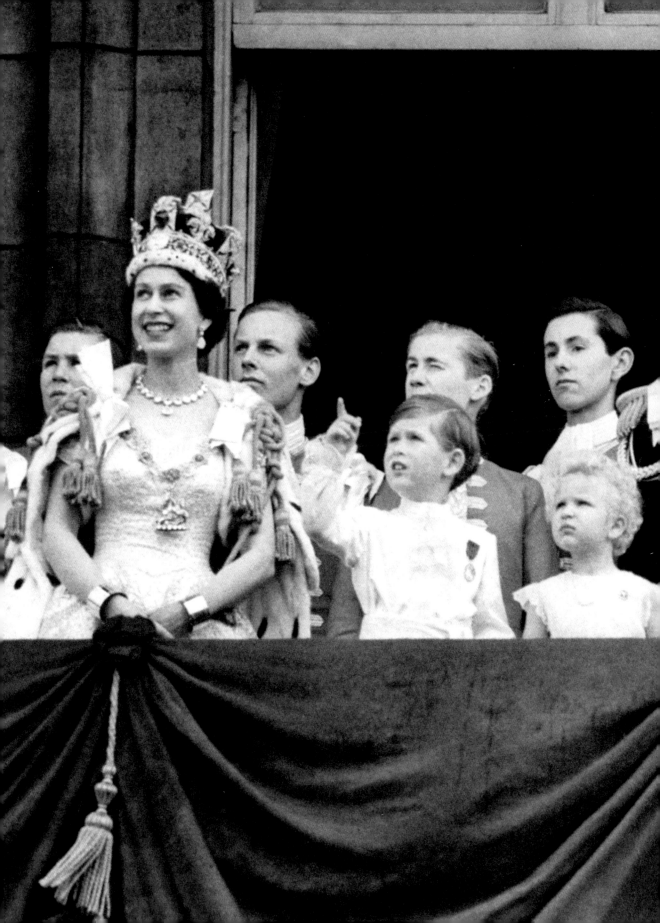

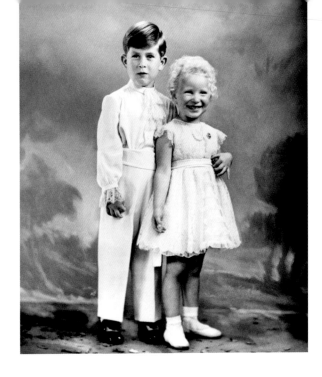

Prince Charles and Princess Anne dressed up for their mother's Coronation Day. Charles later recalled how he had been 'strapped into this outfit' of long trousers and a frilled shirt.

Queen Elizabeth II's, will be a day to remember. One tradition that is firmly in place is the venue, Westminster Abbey, first used for a Coronation on Christmas Day 1066, when King William I – William the Conqueror – was crowned, two months after his victory at the Battle of Hastings. All but two sovereigns have been crowned here ever since. The exceptions were the boy-king Edward V, one of the Princes in the Tower who was monarch, albeit briefly, in 1483; and Edward VIII, who ruled for just 325 days in 1936 but abdicated before his Coronation.

One thing that will certainly be different from the 1953 ceremony is that His Majesty's Queen Consort will be crowned alongside him. The last time this happened was in 1937, when King George VI and his Queen Consort, Elizabeth – King Charles' grandparents – were crowned together. Prince Philip was never King Consort; the husband of a female monarch is officially Prince Consort. Royal tradition dictates that anyone with the title King is the reigning monarch; therefore for Queen Elizabeth II to hold the senior role, Philip could not be given that title.

We have yet to see what Coronation Regalia will be used for King Charles III's ceremony, much of which dates from 1661 and the Coronation of his namesake, King Charles II. Most of the original regalia was destroyed when King Charles I was deposed and the Parliamentarians ruled, so many new items were made for his son, Charles II, after the restoration of the monarchy. Among the new pieces created was St Edward's Crown, used at the very moment of crowning in the

The Coronation Spoon and ampulla. These and other items of Coronation Regalia form part of the Crown Jewels, which are kept in the Jewel House in the Tower of London and guarded by Yeoman Warders.

Coronation ceremony. Another item almost certain to be used is the ampulla, also made for Charles II. Fashioned from gold and shaped like an eagle, it holds the consecrated oil used during the most solemn part of the ceremony: the anointing. It is used with the Coronation Spoon, one of the few items that survived intact when in 1649 Parliamentarian Oliver Cromwell demanded the regalia 'be totally broken' as it was symbolic of what he termed the 'detestable rule of kings'.

A RESPECT FOR ALL FAITHS

The sacred anointing was the one part of Queen Elizabeth II's Coronation that was not broadcast on television. Her Majesty was Defender of the Faith and Supreme Governor of the Church of England (positions now held by her son) and her faith was always of deep importance to her. She made known the strength she took from her Christian faith, as well as her respect for all faiths. During his first public address to the nation as monarch, King Charles III spoke of his faith, deeply rooted in the Church of England. However, he has long held an interest in other religions, seeing the Anglican faith as only one of the common threads linking us all in what he termed 'one great and important tapestry'. During an interview in 1994, when asked about his ultimate Coronation in which he will pledge to be Defender of the Faith, Charles said that he would much rather see his role 'as Defender of Faith, not THE Faith'.

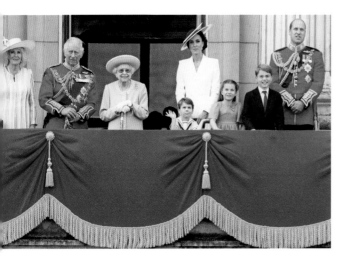

Heirs to the Throne

Queen Elizabeth II's dignity, her grace, her unstinting sense of duty and pride in the role she held for 70 years won her a place in the hearts of the British people throughout her reign. While her passing was – and is – deeply mourned, the warmth with which King Charles III was welcomed to his role as monarch by his subjects following her death left no doubt that he was the man they wanted on the throne.

The Queen had never favoured abdication. In 1936, at the age of ten, she experienced the life-changing event of her parents becoming King and Queen – and she heir to the throne – after her uncle, King Edward VIII, gave up his sovereignty to marry divorcee Wallis Simpson. At the core of her aversion to abdication, though, was the pledge she made on her 21st birthday in a broadcast to the Commonwealth and Empire. This pledge was echoed by her son, King Charles III, during his first address to the nation as sovereign: 'As The Queen herself did with such unswerving devotion, I too now solemnly pledge myself, throughout the remaining time God grants me, to uphold the Constitutional principles at the heart of our nation. And wherever you may live in the United Kingdom, or in the Realms and territories across the world, and whatever may be your background or beliefs, I shall endeavour to serve you with loyalty, respect and love, as I have throughout my life.'

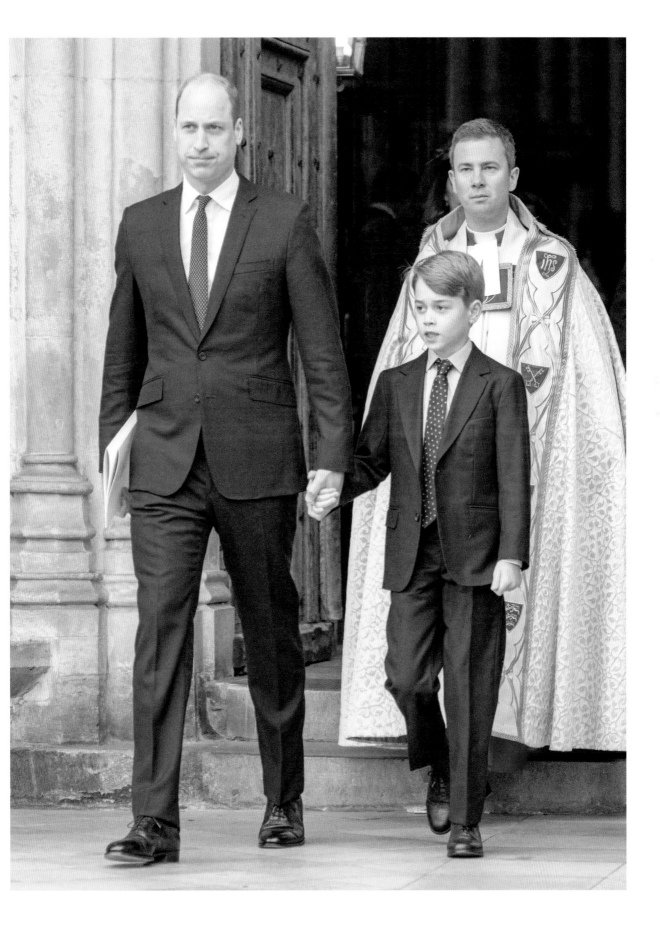

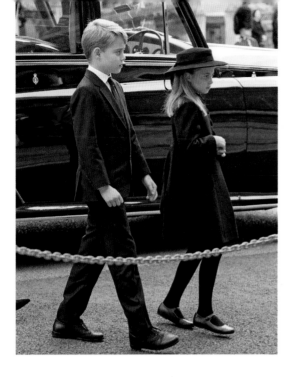

After attending the funeral of their great-grandmother, The Queen, in London, Prince George and Princess Charlotte arrived at St George's Chapel, Windsor Castle on the afternoon of 19 September 2022 for the service of committal.

King Charles III is destined to have a far shorter reign that his mother, as too is his heir apparent, Prince William. William has said that he has no desire to 'climb the ladder of kingship' before his time. When that times comes is for God alone to know, but as he moves towards his destiny one thing is certain: he has the steadfast support of his wife, Catherine, Princess of Wales. Catherine's background is one

PRINCE OF WALES

On the accession of his father on 8 September 2022, Prince William, previously Duke of Cambridge, received the titles Duke of Cornwall, Duke of Rothesay, Earl of Carrick, Baron of Renfrew, Lord of the Isles, and Prince and Great Steward of Scotland. The title Prince of Wales is not an automatic one but in his inaugural speech the following day King Charles announced the creation of William as Prince of Wales. He is the 22nd person to hold the title, which has always been a controversial one. The native Welsh Prince Llywelyn ap Gruffydd (Llywelyn the Last) had refused to submit to King Edward I and was killed in battle in 1282. Two years later came the Statute of Wales, which saw the Principality formally annexed to the English Crown. In 1301, King Edward I's son (later King Edward II) was born at Caernarfon Castle and given the title Prince of Wales. Caernarfon Castle is where Prince Charles was invested at Prince of Wales in 1969, though William has indicated that he does not want the pomp and ritual of a full ceremonial investiture.

of love and stability; when they were no more than girlfriend and boyfriend, on visits to her parents she gave Prince William a taste of a happy family life … and he loved it. But William's life, like his father before him, has been mapped out from the moment he was born. The same is true for William's eldest son, Prince George. Already we see the boy who will one day be King at royal events, behaving impeccably and making his parents proud.

The Prince and Princess of Wales are a golden couple. His mother, Diana, Princess of Wales was the star of the Royal Family in her day, the person everyone wanted at their event – and much the same is true for William and Catherine, who combine the esteemed quality of the common touch with a sprinkle of royal sparkle. In addition, their charitable work and care for the underprivileged is well known and valued hugely. Their sense of duty – a phrase that is now a common thread among senior working members of the Royal Family – gives assurance that, when the time comes, the British monarchy will be in safe hands.

Meanwhile, we can rejoice in the monarch we have, King Charles III, so loyally supported by his Queen Consort. Together this formidable team will ensure the continuity of the British monarchy, overcoming any challenges they may face with the love and affection that so clearly binds them.

William and Catherine made their first visit to the Principality as Prince and Princess of Wales on 27 September 2022, the day after the Royal Family's official period of mourning for The Queen ended. Before travelling on to Swansea, they visited the Royal National Lifeboat Institution on Anglesey where, as seen here, the Princess crouched down to chat with a small boy who presented her with a bunch of flowers.

The Order of Succession

1. Prince William of Wales, The Prince of Wales

2. Prince George of Wales

3. Princess Charlotte of Wales

4. Prince Louis of Wales

5. Prince Harry, The Duke of Sussex

6. Archie Mountbatten-Windsor

7. Lilibet Mountbatten-Windsor

8. Prince Andrew, The Duke of York

9. Princess Beatrice

10. Sienna Mapelli Mozzi

11. Princess Eugenie

12. August Brooksbank

13. Prince Edward, The Earl of Wessex

14. James, Viscount Severn

15. Lady Louise Mountbatten-Windsor

16. Princess Anne, The Princess Royal

17. Peter Phillips

18. Savannah Phillips

19. Isla Phillips

20. Zara Tindall (née Phillips)

OPPOSITE: King Charles and his Queen Consort at Dunfermline Abbey in Fife, 3 October 2022. The royal couple were visiting the former town to mark its new status as Scotland's eighth city, which was granted as part of The Queen's Platinum Jubilee celebrations earlier in the year.

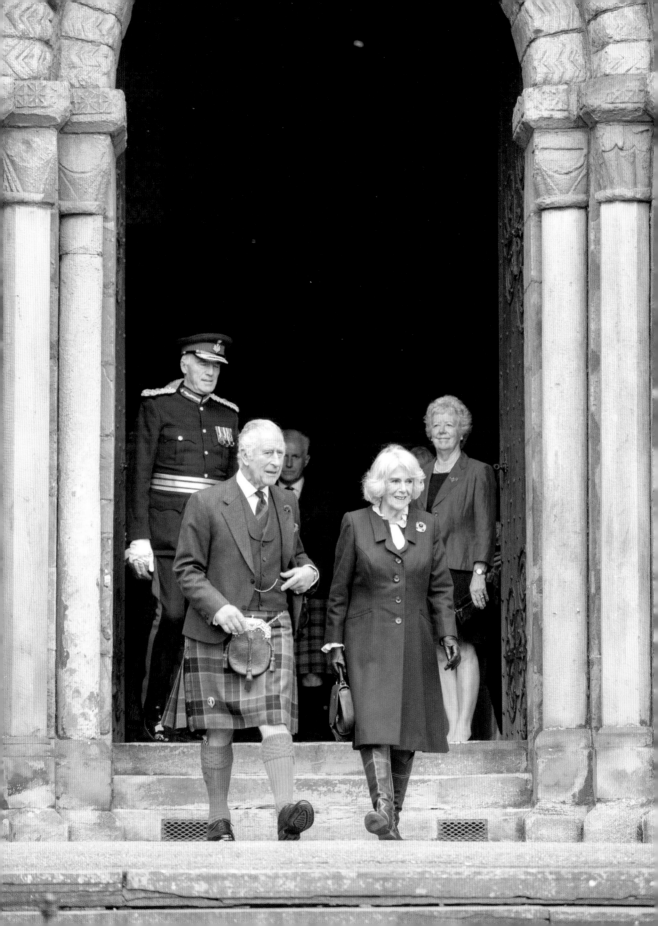

ACKNOWLEDGEMENTS

First published in the United Kingdom in 2023 by
Pitkin Publishing
43 Great Ormond Street
London WC1N 3HZ
Pitkin Publishing is an imprint of B.T. Batsford Holdings Ltd

Copyright © Pitkin Publishing, 2023
Text by Gill Knappett; the author has asserted her moral
rights. The text is based on *Charles, Prince of Wales* by
Gill Knappett (Pitkin Publishing, 2018).
Designed by Kei Ishimaru
Proofread by Clare Sayer

All photographs used by kind permission of Alamy

ISBN 978-1-84165-966-4 1/23
A CIP catalogue for this book is available from the
British Library.

Reproduction by Rival Colour Ltd, UK
Printed and bound by Bell & Bain, UK

FRONT COVER: Charles, as Prince of Wales, wore the
ceremonial uniform of the Welsh Guards for this official
portrait taken by society photographer Hugo Burnand
to mark His Majesty's 60th birthday in 2008.

PAGE 1: Prince Charles at Cirencester Park Polo Club,
Gloucestershire in the 1980s.

PAGE 2: King Charles III (then Prince of Wales) in 2016.

PAGES 4–5: Prince Charles and the Duchess of
Cornwall on their annual tour of Wales in 2006. They
were on a clifftop path on the Gower Peninsular, which
was celebrating 50 years of being declared an Area of
Outstanding Natural Beauty.